Walt <!-- barcode overlaps name --> was born in Columbus, Ohio, in 1932.
He obtained his BFA (*cum laude*) and MA at Ohio State
University and was awarded a Harvard PhD in 1969 for his
dissertation on *The Paintings of Cornelius Engebrechtsz*. He has
spent two periods of research at the Kunsthistorisch Institut
Rijksuniversiteit, Utrecht, and his awards and honors include
a Guggenheim Fellowship in 1978–79 and a Fulbright
research grant to Belgium in 1984. He has taught in the
Department of Art, Case Western Reserve University, Ohio,
since 1966 and is now Andrew W. Mellon Professor in the
Humanities. Professor Gibson's special interest lies in six-
teenth-century Dutch and Flemish painting and his other
books include *Hieronymus Bosch* (World of Art) and *Mirror
of the Earth: The Flemish World Landscape of the
Sixteenth Century.*

WORLD OF ART

This famous series
provides the widest available
range of illustrated books on art in all its aspects.
If you would like to receive a complete list
of titles in print please write to:
THAMES AND HUDSON
30 Bloomsbury Street, London WC1B 3QP
In the United States please write to:
THAMES AND HUDSON INC.
500 Fifth Avenue, New York, New York 10110

BRUEGEL

WALTER S. GIBSON

153 illustrations, 20 in color

THAMES AND HUDSON

Any copy of this book issued by the publisher as a
paperback is sold subject to the condition that it shall not
by way of trade or otherwise be lent, resold, hired out or
otherwise circulated without the publisher's prior
consent, in any form of binding or cover other than that
in which it is published and without a similar condition
including these words being imposed on a subsequent
purchaser.

© 1977 Thames and Hudson Ltd, London

First published in the United States in 1985 by Thames
and Hudson Inc., 500 Fifth Avenue, New York,
New York 10110
Reprinted 1991

Library of Congress Catalog Card Number 88–50149

All Rights Reserved. No part of this publication may be
reproduced or transmitted in any form or by any means,
electronic or mechanical, including photocopy, recording
or any other information storage and retrieval system,
without prior permission in writing from the publisher.

Printed and bound in Spain
by Artes Graficas Toledo S.A.
D.L. TO 1991–1990

CONTENTS

To
Irene Heppner
with affection
and in memory of
Albert Heppner

Preface

The current scholarly preoccupation with the iconography of Pieter Bruegel the Elder has greatly enhanced our understanding of his subject-matter. It has tended, however, to dull our perception of Bruegel's other qualities: his robust humour, his keen observation of human physiognomy, and, above all, the visual imagination which enabled him to transform even the most banal ideas of his age into powerful and unforgettable images. These other aspects must also be considered before we can fully appreciate Bruegel's artistic achievement.

This is the premise of the present survey of Bruegel's drawings and paintings, which also explores his relationship to the artistic and cultural milieu in which he worked. I have given particular attention to the literature of the Netherlandish *rederijkers*, whose significance is still underestimated. Limitations of space have not permitted a discussion of the so-called *naer het leven* drawings (drawings 'after life'), but it should be noted here that the perceptive studies of Van Leeuwen and Spicer clearly show that most of the sheets in this group cannot be attributed to Bruegel. The question of Bruegel's artistic relationship to his putative teacher Pieter Coecke van Aelst and the anonymous Brunswick Monogrammist is a subject which I hope to examine more extensively on a future occasion.

The preparation of this book was substantially aided by a grant from the American Council of Learned Societies for research in Europe. I would like to express my deep gratitude to the Council, and to Case Western Reserve University for a grant to purchase photographs. For advice on many points in my research, I am much indebted to Dr Charity Cannon

Willard, as well as to Professor Dr J.G. van Gelder, Mr E. de Jongh, Dr A. Monballieu, Mrs Yoko Mori, Dr Edward Olszewski, Dr Conrad Rawski, Dr Philips Salman, Dr Susan Urbach and Mrs Wendy Wood. I am particularly grateful to Count Antoine von Seilern for a delightful afternoon spent in examining his collection, to Mr Gerbrand Kotting for assistance generously given on numerous occasions, and to Mrs Alice Loranth, Director of the John G. White Collection, Cleveland Public Library. The superb collection of proverb literature in the White Collection greatly facilitated my research. For their assistance in seeing works of art or obtaining photographs, thanks are extended to Mr Robin Adèr, Mr John Hand, Mr Carlos van Hasselt, Mlle L. van Looveren, Dr A.W.F.M. Meij, Dr Silvia Meloni, Mr Henri Pauwels, Dr Lilian Randall, Miss Louise Richards, Mrs Evelyn Semler, Ms Felice Stampfle, and Mr Arthur Wheelock, Jr.

My warmest thanks, however, are reserved to Miss Jean Anne Vincent and my wife Sally who read and commented on earlier drafts of the text. The final draft was expertly typed by Miss Carolyn Moore.

The dedication, in part, acknowledges a debt to the work of Albert Heppner, the German art historian whose promising career was cut short by the Nazis in the Second World War. It was his classic study on Jan Steen and the popular theatre which, years ago, first introduced me to the fascinating world of the *rederijkers*.

W.S.G.

Introduction

Pieter Bruegel the Elder belongs, with Michelangelo, Rembrandt and Van Gogh, to that select company of artists who enjoy almost universal esteem in our time. Bruegel's landscapes and peasant scenes hang on the walls of innumerable homes and offices; they decorate record jackets and the lids of cigarette boxes. At least one of his paintings, the *Children's Games*, has been reproduced as a jigsaw puzzle. His pictures have inspired poems and his life has been the subject of a novel. When tourists visit the Kunsthistorisches Museum in Vienna, they may glance only perfunctorily at Titian's mythologies or Albrecht Dürer's religious pictures, but they usually linger in the Bruegel gallery. Here, surrounded by the finest collection of Bruegel's paintings in the world, they examine each work with interest and delight, often chuckling over its details, before moving on to the next picture.

The reasons for Bruegel's enormous popularity in the twentieth century are not far to seek. His well-fed, jolly peasants seem to belong to an Arcadian past which knew nothing of nuclear weapons, energy crises and other problems besetting modern life. His vast glowing landscapes offer a welcome relief from the brick and concrete drabness of our environment, and his strong colours and bold compositions appeal to the modern taste for abstract design.

Although his pictures have thus become a familiar part of our daily lives, Bruegel himself remains an enigmatic and misunderstood figure. It was formerly believed that he was a rather crude fellow who played practical jokes on his friends and painted funny pictures to make people laugh. 'There are

few works by his hand which the observer can contemplate with a straight face. However still and morose he may be, he cannot help chuckling or at any rate smiling,' wrote Karel van Mander, the early seventeenth-century Dutch art historian and Bruegel's first biographer. Van Mander claimed that Bruegel had been born a peasant, apparently assuming that only a peasant could have so faithfully rendered the labours and pleasures of rustic life. He also praised Bruegel for his 'spookish scenes and drolleries' after Hieronymus Bosch.

Van Mander's views were accepted by the critics and connoisseurs of later centuries who found the epithets 'Pieter the Droll' and 'Peasant Bruegel' apt descriptions of both the man and his art. This image of Bruegel persisted even after serious study of his work had begun in the late nineteenth century. For Friedländer and other early scholars, Bruegel was still the humourist whose scenes of peasants, proverbs and folklore were destined chiefly to entertain the man in the street.

This view, however, was challenged by later scholars, who correctly pointed out that Bruegel's paintings had been collected by some of the wealthiest and most cultivated members of Flemish society in his day. Moreover, one of his friends was the famous geographer and cartographer Abraham Ortelius. The close relationship between these two men is clearly revealed in a eulogy in Ortelius's *Album Amicorum*, or friendship album. Writing several years after the artist's death, Ortelius recorded his warm regard for Bruegel and his art. The distinguished circle in which Bruegel thus seems to have moved suggests that he was scarcely a peasant, but probably a man of some education and culture. It is also likely that his paintings and drawings were often more serious in meaning than Van Mander implied.

The research of these later critics, including De Tolnay and Stridbeck, has provided a welcome corrective to the earlier conceptions of Bruegel. But in their zeal to transform 'Peasant Bruegel' into a suitable companion for gentlemen and princes, they have exaggerated the intellectual aspects of his art. It is

widely assumed that most of Bruegel's pictures express profound philosophical or moral concepts, often embodying a pessimistic view of mankind. Even his rollicking peasant scenes, which might be thought to be among his least ambiguous subjects, have been seen as elaborate allegories of human folly. In the *Peasant Wedding Feast*, for example, the bride has been interpreted as the sinful Church abandoned by Christ, and as the personification of Generosity whose munificence is abused by the world. Unfortunately, neither interpretation is supported by what Bruegel's contemporaries thought about either peasants or personifications, and the ingenious explanations proposed for others of his works also fall, under closer scrutiny.

It is possible that modern scholars have been misled by a passage in Ortelius's eulogy in which he tells us that Bruegel 'depicted many things that cannot be depicted, as Pliny says of Apelles. In all his works more is always implied than is depicted. This was also said of Timanthes.' That Ortelius was not referring to allegories, however, is clear from his allusions to Apelles and Timanthes, two ancient painters praised by Pliny the Elder, one for his depictions of lightning and thunderbolts, the other for his ingenuity in portraying human grief. There is little evidence, in fact, that Bruegel's pictures are as recondite or cryptic as is so often believed.

This is not to deny, of course, that Bruegel shared the predilection of his age for symbolism and allegory. His symbolism, however, was largely traditional; his moralizing treatment of subjects was often anticipated in the popular Flemish prints of the day. But there were many occasions, too, when he represented nature and his fellow men not so much as symbols of hidden truths, but more for themselves, and through much of his work, even his allegories, there runs a magnificent strain of humour too often overlooked by modern scholars. Van Mander, as we shall see, was not completely wrong in his description of Bruegel's art.

Similar problems arise in the attempts to characterize Bruegel's style and to indicate his place in the history of

sixteenth-century Flemish art. An older generation, still influenced by Van Mander's account, saw Bruegel primarily as the robust Flemish realist, consciously rejecting the effete Italianizing style prevailing among the other Netherlandish artists to return to a native tradition. More recent critics claim, on the contrary, that Bruegel was the major Flemish representative of European Mannerism, displaying the same aesthetic preoccupations and spiritual tensions that we find in Michelangelo, Tintoretto and El Greco. Neither generalization gives an adequate explanation of his art. The first ignores the influence of Italian painting, which played an important role in his later work, including the *Peasant Wedding Feast* and the *Peasant Kermis*, and both generalizations obscure the close relationship between Bruegel and other Flemish artists of his time.

It is clear, therefore, that Bruegel cannot be understood apart from his particular artistic and social milieu. This is even truer for Bruegel than it is for his great predecessor Hieronymus Bosch, with whom he is often compared. The earlier artist depicted the universal Christian themes of sin, death and salvation. To a great extent, Bosch's literary and visual sources were the common heritage of the Middle Ages. The subjects represented by Bruegel were also of universal significance, but his interpretation of them was often more topical, more directly expressive of the bustling cosmopolitan society in which he lived and worked. As the careful studies of Grauls and Lebeer have demonstrated, Bruegel's inspiration must be sought in the popular theatre and in holy day processions, in local folklore and proverb books. His works reflect the tastes and attitudes of the bankers, merchants and humanists who commissioned his paintings, or bought the prints published after his drawings. That is why any account of Bruegel's art must include a description of the brilliant Flemish culture which flourished in his lifetime.

Bruegel and the Flemish Renaissance

What little we know of Bruegel's life is supplied chiefly by Karel van Mander's biography of the artist, written a generation after his death, supplemented by a few contemporary records and references. Perhaps on the assumption that Bruegel's surname reflected his place of origin, Van Mander claimed that he had been born near Breda, in the village of Bruegel or Brögel. There are, however, two villages of that name, neither near Breda; in Bruegel's lifetime, moreover, a contemporary (Ludovico Guicciardini) referred to him as 'Pieter Bruegel of Breda', and it is likely that he was born in this town in northern Brabant, seat of the Counts of Nassau since the fifteenth century.

The year of Bruegel's birth is equally uncertain. In an engraved portrait published in 1572 he appears between forty and forty-five years of age. The portrait was probably made shortly before he died in 1569, for Ortelius's eulogy describes him as being taken away 'in the flower of his age', suggesting an early death. Hence it may be assumed that Bruegel was born sometime between 1524 and 1530. On the basis of an inscription accompanying a later portrait of Bruegel, engraved in 1606, two scholars have recently attempted to fix his birth date more precisely to the years 1527–8.

Bruegel's career is not documented before 1550, but Van Mander tells us that he was trained by Pieter Coecke van Aelst. Active from 1527 on, first in Antwerp and then in Brussels, Coecke was a leading Flemish artist of his day, and supervised an extensive workshop. His numerous altarpieces, panels and tapestry designs reveal the strong influence of Raphael and his

1

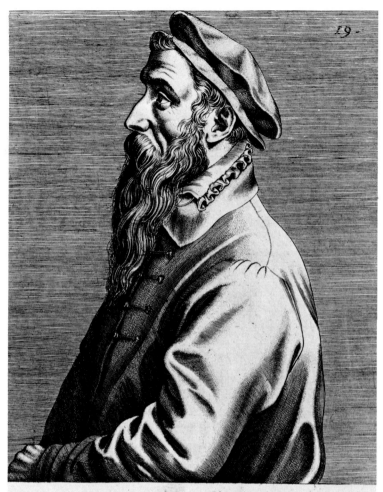

PETRO BRVEGEL, PICTORI.

Quis nouus hic Hieronymus Orbi Macte animo, Petre, mactus vt arte,
Boschius? ingeniosa magistri Namque tuo, veterisque magistri
Somnia peniculoque, styloque Ridiculo, salibusque referto
Tanta imitarier arte peritus, In graphices genere inclyta laudum
Vt superet tamen interim et illum? Præmia vbique, et ab omnibus vllo
 Artifice haud leuiora mereris.

1 Pieter Bruegel the Elder in 1572

school. He also published a Netherlandish translation of a
treatise by the famous Italian architect Sebastian Serlio. Despite
occasional attempts of scholars to prove the contrary, the
learned and sophisticated Coecke seems to have had little effect
on Bruegel's art. For this reason, Van Mander's account has
been doubted by several writers, who also note that Bruegel's
name is not listed among Coecke's pupils registered in the
Antwerp Artists' Guild. Nevertheless, Bruegel may have been
associated with Coecke only after the latter's move to Brussels,
sometime after 1544. Like other Flemish artists of the period,
moreover, Coecke seems to have employed landscape-
specialists to complete the backgrounds of his pictures. The
young Bruegel may well have performed such a function in
Coecke's workshop, and it is possible that his earliest efforts at
landscape-painting have survived unrecognized in some of
Coecke's altarpieces and devotional panels.

Although Bruegel's relationship with Coecke remains a
matter of speculation, there *is* evidence that he collaborated
with other artists. In 1551, the year after Coecke's death in
Brussels, Bruegel is recorded in the workshop of Claude Dorizi,
an artist and art-dealer in Malines. Here he helped to paint an
altarpiece commissioned from Dorizi by the local glovemakers'
guild. The work has been lost and the records are vague, but
Bruegel apparently executed the outer wings in grisaille,
depicting two saints standing beneath a tree. The most
important parts of the altarpiece, the inner panels, were
completed by Pieter Baltens, some years Bruegel's elder and a
master in Antwerp since about 1539. The few surviving
paintings by Baltens recall Bruegel in style, but nothing can be
deduced from this association between the two artists save that
Bruegel seems to have worked in a subordinate role. It has been
conjectured that Bruegel obtained this commission through
Coecke's widow, Marie Verhulst, who came from a family of
artists in Malines. Significantly, Malines was also a major centre
of tempera-painting on canvas, a technique in which Bruegel
later frequently worked. Perhaps he learned it here, although he

2 Pieter Coecke van
Aelst *The Resurrection
of Christ*

could have received instruction even earlier from Marie
Verhulst, who also seems to have practised this mode of
painting.

Bruegel did not remain long in Malines; the rolls of the
Artists' Guild of Antwerp register his admission as a master
painter there in 1550–1, and shortly afterwards he departed for
southern Europe. Van Mander tells us no more than that he
travelled in France and Italy and through the Alps, but his
itinerary can be partially reconstructed from the paintings and
drawings he made during the trip, as we shall see. That he
returned to Antwerp no later than 1555 we know from the
earliest date to appear on his drawings done for Hieronymus
Cock.

Cock was the foremost publisher of prints in the Netherlands
during this period. His publishing house, the Quatre Vents
(Four Winds), had been established about 1550, and during the
next two decades he issued almost a thousand etchings and

engravings. A good businessman, he appealed to an international public with an astonishing variety of subjects: landscapes, maps and topographical prints, didactic scenes in the style of Hieronymus Bosch, and compositions after the most eminent Italian and Netherlandish artists of the day. Bruegel seems to have been associated with the shop of the 'Four Winds' on a fairly regular basis; between 1555 and 1563, when he left for Brussels, he produced almost forty drawings for Cock's engravers. His work for Hieronymus Cock undoubtedly introduced him to Ortelius and other members of the intellectual circles in Antwerp and Brussels.

Except for two landscapes of 1553 and 1557, Bruegel's earliest dated paintings are the *Netherlandish Proverbs* and the *Carnival and Lent* of 1559, and the *Children's Games* of 1560. Sometime in 1559, he changed the spelling of his name from Brueghel to Bruegel, the form with which he consistently signed his works thereafter. He may have been in Amsterdam in 1562, the date inscribed on three of his drawings which depict the walls and towers of that city, but the purpose of this visit is not known.

The following year Bruegel moved to Brussels and married Mayken, the daughter of Pieter Coecke. Van Mander tells the charming story that Bruegel had carried Mayken around in his arms as a child while he was apprenticed to her father. The marriage took place in 1563. The couple had two children, Pieter and Jan, born in 1564 and 1568 respectively.

Although Bruegel continued to make designs for Hieronymus Cock, he concentrated on paintings, creating his greatest masterpieces during the last five years of his life. Among them are the *Labours of the Months* and the scenes of peasant revelry. In addition to Abraham Ortelius, his patrons included Cardinal Granvella, counsellor to the Regent Margaret of Parma, and the wealthy Antwerp banker and royal official Niclaes Jonghelinck. Another patron was his friend the German merchant Hans Franckert, for whom 'Bruegel did a great deal of work', as we are told by Van Mander. From the same source we learn that the magistrates of Brussels

commissioned Bruegel to paint a series of pictures commemorating the completion of a large canal, but that the work was interrupted by his untimely death. This occurred on 9 September 1569, and Bruegel was buried in the same church where he and Mayken had been married scarcely six years before.

Bruegel's career coincides with the most brilliant phase of the Flemish Renaissance. During most of the sixteenth century the Netherlands enjoyed great material prosperity. Her agriculture and industry, and especially her commerce, generated an unprecedented wealth which was the envy of all Europe. In 1559, four years after the country had been ceded by Emperor Charles V to his son Philip II of Spain, a Venetian ambassador acutely remarked that the true mines of the Spanish Empire lay not in America but in the sodden clay of the Netherlands. The flourishing condition of the country was vividly depicted by the Italian banker and historian Ludovico Guicciardini in his *Description of All the Lowlands*, first published in Antwerp in 1567. The Netherlands possessed about twelve thousand villages and over two hundred walled cities, making it one of the most densely populated areas in Europe. Guicciardini described many of these places in detail, including the cities in Brabant most closely associated with Bruegel, Breda, Malines, Antwerp and Brussels, but it was to Antwerp that he devoted his longest and most enthusiastic account.

After 1499, when the Portuguese merchants transferred their spice market from Bruges to Antwerp, the latter city quickly grew into one of the most powerful commercial and financial centres of western Europe. Ships from all countries lay anchored in her great harbour on the Scheldt River; foreign merchants and bankers thronged her streets and exchanges; and the rulers of Europe sent agents to Antwerp to negotiate loans to finance their perpetual wars. Antwerp's international significance is well expressed in the inscription which proudly adorned the façade of the new stock exchange completed in 1531: 'For the service of merchants of all nations and languages.'

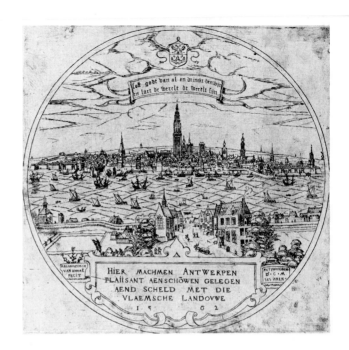

3 View of Antwerp
in 1562

And in a Flemish play of 1561, one of the characters tells the audience: 'When I name Antwerp, you think you hear the names of Venice, Florence, Genoa, Naples, Augsburg, Cologne, Lyons and Paris, for all these come together in Antwerp for the pursuit of trade.'

Chiefly because of her commercial importance, Antwerp doubled in population during the first half of the century, reaching a total of about one hundred thousand inhabitants by 1550. New public buildings arose within her walls and luxurious mansions and villas filled her rapidly growing suburbs. This building activity culminated in 1564 with the completion of the new town hall, an imposing structure in the Flemish Renaissance style and the largest secular building in sixteenth-century Netherlands.

Some idea of the city's appearance can be gained from an etching of 1562. 'Here one may see Antwerp,' says the 3
inscription below, 'lying pleasantly on the Scheldt with its

Flemish meadows.' Beyond the village in the foreground and the river dotted with ships, we can see the city, her many walls, docks and towers crowned by the tall spire of her chief church, the Church of Our Lady. Above the church appears another inscription. 'Praise [the] God of all and drink the wine, and let the world be the world.' These words well express the tolerant, worldly attitude of Antwerp's inhabitants. The Church of Our Lady still dominated the market-place much as it had in the Middle Ages, but the merchants, bankers and industrialists were as much concerned with the profits and pleasures of this life as with preparations for the life to come. The Reformation had spread throughout the Netherlands, but while Protestants were occasionally martyred for their faith, the civil authorities of Antwerp and other Netherlandish cities resisted the efforts of the Church to organize large-scale persecutions. The Inquisition was generally feared and hated, partly from a genuine belief in religious freedom, but also from the firm conviction that intolerance was bad for business.

With her wealth and cosmopolitan milieu, Antwerp soon became a major centre of European culture. Her publishing houses rivalled those of Paris and Lyons in number and importance, and included the famous firm established by Christopher Plantin in 1555. The presses of Plantin and others produced an unending stream of books in many languages, ranging from medieval devotional treatises to new editions of the classical authors, from crudely illustrated folk-books to elegantly printed volumes by the leading humanists of the day. Erasmus had frequently visited Antwerp, where his works were still being published and read in the mid-sixteenth century; the esteem in which his memory was held is indicated by the two engraved portraits of him issued by Hieronymus Cock in 1555. Many other scholars were attracted to Antwerp, among them Gerardus Mercator and Abraham Ortelius. These two geographers greatly improved the science of cartography, and their maps and atlases disseminated the discoveries of the New World throughout Europe.

20

Right at the centre of Antwerp's literary and festive life were the *rederijker kamers*, or chambers of rhetoric. Drawing their members chiefly from the middle classes, these societies presented poetic and dramatic performances on public occasions, participated in carnival revelry, welcomed visiting dignitaries and organized the allegorical floats which formed a conspicuous part of the annual religious processions. Almost every town in the Netherlands had at least one *rederijker kamer*, and Antwerp possessed three, of which the Violeren (Gillyflower) was the oldest and most prestigious. These societies reached the height of their fame and influence during Bruegel's lifetime, and in 1561, just two years before he moved to Brussels, the Violeren invited all the chambers in Brabant to Antwerp for a great *landjuweel*, or dramatic competition. Prizes were awarded for the best performances, and the proceedings were distinguished by a splendid procession and other ceremonies lasting several weeks.

Rederijker drama consisted largely of farces and allegorical plays. The farces usually presented amusing episodes from peasant life, while the allegories were more serious. Descended from medieval morality plays, of which *Everyman* is perhaps best known to the modern reader, these dramas abound with personifications of the Virtues and Vices, often quite fanciful in appearance and nomenclature. Their florid dialogue and stilted action have won these plays few modern admirers, and were occasionally criticized by contemporaries. Yet they performed an important social role; intended to instruct and edify, they often expressed the ideals, hopes and fears of their audiences.

The *rederijkers* numbered many artists among their members. United with the Antwerp Artists' Guild since 1481, the Violeren was, in fact, composed almost exclusively of painters and printmakers. Among them were Hieronymus Cock, Pieter Baltens and Frans Floris; another member was Bruegel's friend Hans Franckert. While we have no documentary evidence that Bruegel himself was active in *rederijker* circles, his familiarity with their performances is demonstrated in his *Allegory of*

4 *Temperance*, a drawing of 1560 depicting a *rederijker* drama in progress. The personifications of Hope and possibly Faith appear on stage, while a fool peers out from behind a curtain. Many parallels with *rederijker* literature can also be found in Bruegel's art, especially in his allegorical subjects.

The fame of the Antwerp *rederijkers* probably did not extend much beyond the borders of the Netherlands, but the Antwerp painters achieved an international reputation, and their art was exported all over Europe. During the course of the century the city had become a veritable picture-factory. According to Guicciardini, three hundred masters were working there in 1567, some of whom directed large workshops in which the process of picture-making was divided among many assistants. The collaboration of Bruegel and Baltens in Malines indicates that similar workshops existed elsewhere in the Netherlands, but Antwerp contained the greatest number.

Sixteenth-century Netherlandish painting displays a rich diversity of styles and influences; in general, however, two distinct tendencies can be discerned. The first style was characterized by idealized figures influenced by Italian and antique art, and was especially favoured for monumental altarpieces and other religious pictures, and for paintings and tapestries destined for palaces and public buildings. Pieter Coecke was an important exponent of this 'official' style; his successors include Frans Floris, praised by Guicciardini for his rendering of muscles in the Italian manner, and Maerten de Vos, both of whom worked in Antwerp. Equally important was the gifted draughtsman and painter Maerten van Heemskerck of Haarlem. Hieronymus Cock published many engravings after these artists, especially Heemskerck.

Alongside these artists were others who worked in a less idealized style, producing pictures of landscapes and genre subjects. Although they were occasionally affected by Italian art, especially in the rendering of the human figure, they display a taste for realistic details drawn from everyday life, continuing the tradition of fifteenth-century Flemish painting. The artists

22

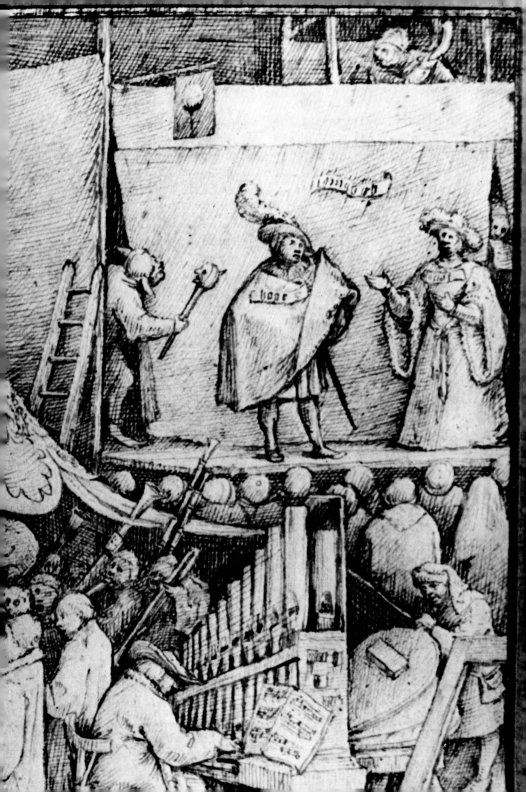

of this 'indigenous' style tended to specialize in certain types of subject-matter. Thus Marinus van Roemerswaele painted a series of half-length pictures satirizing avaricious bankers and tax-collectors, while tavern and brothel scenes were favourite subjects of Jan Massys and Jan Sanders van Hemessen. In Bruegel's day, Pieter Aertsen and his nephew Joachim Beuckelaer specialized in market and kitchen scenes.

Landscape-paintings, however, enjoyed the greatest vogue with the picture-buying public. Already in the earlier sixteenth century Joachim Patinir had won fame for his numerous pictures of religious figures placed before immense vistas composed of many scenic elements seen in bird's-eye perspective. Steep mountains, valleys, rivers and fields, towns and villages follow each other in rapid succession to the distant horizon. The modern German term for these panoramic views, *Weltbilder* (world pictures), is entirely appropriate, for they mirror something of the extent and diversity of the earth's surface. Patinir's cosmic landscape style was developed and modified by a host of followers, of whom the most important was Herri met de Bles, first recorded in Antwerp in 1535. Bles's innovations included a greater use of atmospheric perspective and, in his later works, more unified compositions. In the 1540s, Hieronymus Cock and his brother Matthys produced many landscape-drawings, some of which Hieronymus later published as prints.

Michelangelo had belittled the Flemish artists, who (he claimed) could paint only 'the green grass of the fields, and the shadow of trees and rivers and bridges'; but his was a minority opinion, for their landscapes were avidly collected all over Europe. The Florentine painter Giorgio Vasari wrote that there was no cobbler's house in Italy without a Flemish landscape, and the Spanish historian Felipe de Guevara ranked Patinir among the three greatest Netherlandish artists, along with Jan van Eyck and Roger van der Weyden. The popularity of the Flemish landscapes is not difficult to understand. Their exotic rock-formations and limitless vistas undoubtedly appealed to a public

24

5 Joachim Patinir *The Penitence of St Jerome*

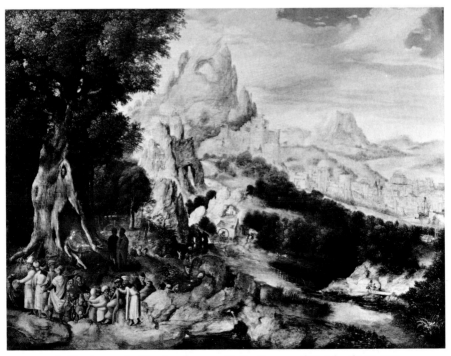

6 Herri met de Bles *Landscape with the Sermon of St John the Baptist*

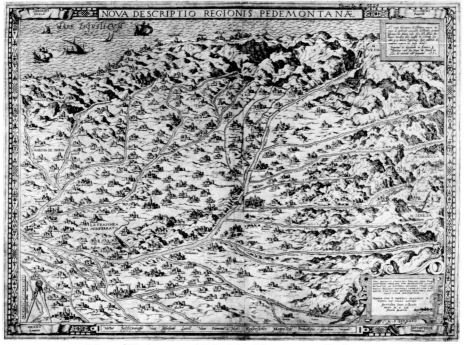

7 Map of Piedmont published by Hieronymus Cock 1552

whose knowledge of the world was being expanded in all directions. Their topographical style also reflects the contemporary enthusiasm for maps, which went far beyond their strictly utilitarian or scientific function. Renaissance cartographers enlivened their maps with realistically rendered details and often presented bird's-eye views not unlike landscape-paintings in effect. When Abraham Ortelius published his great atlas of 1570, the *Theatrum Orbis Terrarum* (*Theatre of the Orb of the Earth*), a friend wrote: 'I felt a great regard for you on account of the singular erudition shown in your *Theatrum* in which you . . . compress the immense structure of land and sea into a narrow space and have made the earth portable, which a great many people assert to be immovable.' Similar feelings must have stirred the viewers of a picture by Patinir or Herri met de Bles, and there is no doubt that Bruegel had studied their landscapes before he departed on his journey south about 1551.

7

The Alpine experience

We can glean some idea of Bruegel's tour of southern Europe and the Alps from a painting and a number of drawings made on his travels, and from references to him in several sixteenth-century documents. On his way to Italy he seems to have stopped at Lyons in southern France, then a large city with many commercial ties with Antwerp: it was probably then that he painted the view of Lyons later owned by Giulio Clovio. Thereafter, Bruegel travelled in southern Italy and Sicily, and perhaps witnessed the attack of the Turkish fleet against Reggio in Calabria, in July 1552. A drawing of a burning city (in Rotterdam) supposedly records this event. His *View of the Bay of Naples* (Rome, Palazzo Doria) has been cited as evidence of a visit to that city. He also seems to have visited the Bolognese geographer Scipio Fabius, who in letters of 1561 and 1565 to Ortelius conveyed his greetings to Bruegel and Maerten de Vos. De Vos is recorded in Italy in the early 1550s, as was the sculptor Jacob Jonghelinck, brother of Bruegel's later patron Niclaes Jonghelinck, and it has been suggested without further proof that the two men and Bruegel were travelling companions.

A drawing of the Roman port of Ripa Grande and a view of Tivoli later engraved by Hieronymus Cock attest to Bruegel's presence in Rome. That this occurred in 1553–4 can be deduced from inscriptions on two etchings and a drawing, all copies of original drawings now lost. It was undoubtedly in Rome that Bruegel met Giulio Clovio, the famous Croatian miniaturist who worked in the style of Michelangelo. An inventory of Clovio's property made in 1577 lists four paintings acquired from Bruegel; the *View of Lyons* previously mentioned, a *Tower*

of Babel painted on ivory, a study of a tree on linen, and a miniature, subject unspecified, in which Bruegel had collaborated with Clovio. In this last work, Bruegel very likely added a landscape to one of Clovio's figure compositions.

Bruegel's journey to Italy was not unusual. By the mid-sixteenth century a number of Netherlandish artists had been there, including Pieter Coecke, Heemskerck, Frans Floris and probably Hieronymus Cock. Bruegel's collaboration with Clovio reflects an equally common practice. Because of their reputations as landscapists, the Netherlanders were frequently engaged as background-painters in the large Italian workshops of the period. Vasari tells us, for example, that Titian employed a number of 'German' (Flemish) artists for this purpose, and Maerten de Vos painted landscapes in the studio of Tintoretto. But however they supported themselves, most Northern artists regarded Italy as the mecca of ancient and Renaissance art, which they diligently studied in order to form or improve their own styles. In this, Bruegel was distinctly unusual, for he seems to have drawn little else but landscapes during his stay in Italy. It is possible, as some scholars have suggested, that he had been specifically commissioned by Cock to gather material for landscape-prints later published by the shop of the 'Four Winds'.

None of the pictures owned by Clovio has survived. Bruegel may well have collaborated with the miniaturist more than once, but it is difficult to detect his activity in any of Clovio's manuscripts, although at least one scholar has attempted to do so. Nevertheless, Bruegel's earliest works come from the Italian journey. One of these is a drawing signed and dated 1552, depicting a landscape perhaps of south Italian origin. The background is occupied by a chain of gently rolling hills, with a cloisters nestling at their feet. In spite of the addition of watercolour by a later hand and the reworking of some foreground details, elements of Bruegel's characteristic drawing can easily be seen. They are especially evident in the dotted technique of the background foliage and the broader,

8 *Mountain Landscape with Italian-Style Cloisters* 1552

more vigorous pen strokes which define the trees in the foreground. The informality of the composition suggests that this sketch was a study from nature.

From the following year, 1553, comes Bruegel's earliest signed and dated painting, the *Christ on the Sea of Tiberias*. At lower left, Christ directs the Apostles to cast their nets in the water, as described in John 21:6–23. The sheep on the path behind him allude to another episode in the same chapter (21:16), where Christ commands Peter to 'feed my sheep'. The figures, probably added by another hand, are distinctly Italianate in style, but the landscape is typically Flemish with its elevated viewpoint and relatively high horizon. The division of the terrain by a broad strip of water receding into space reverts to a composition employed several times by Patinir, most notably in his *Charon Crossing the River Styx* (Madrid, Prado). The chalky blue and green tonalities and the picturesque rock-

11

29

formations behind Christ recall Herri met de Bles. Bruegel differs from these older masters chiefly in his simpler topography and the more plastic modelling of the cliffs and rocks. After the realism of the *Landscape with Italian-Style Cloisters* of 1552, the *Christ on the Sea of Tiberias* may come as a surprise, but the differences between the two works are explicable. The drawing was presumably made for Bruegel's own instruction and enjoyment; to judge from its relatively large scale (about three feet wide), the painting must have been commissioned by some patron, perhaps in Rome, and its rather old-fashioned qualities testify to the continuing vogue in Italy for landscapes in the style of Patinir and Bles.

Although the *Christ on the Sea of Tiberias* remains faithful to Flemish traditions, Bruegel was not blind to the work of 9 contemporary Italian landscapists. In the *Landscape with River and Mountains*, a drawing dated 1553, the little hillock and tall tree framing the scene at left are reminiscent of Herri met de Bles, but the transition from one part of the landscape to another shows a new subtlety which suggests that Bruegel had studied the landscapes of Domenico Campagnola. Italian influence can also be discerned in some landscape-drawings in which trees, not mountains, dominate the composition. One of 10 the most striking sheets in this group is the *Forest Landscape with Bears* of 1554. More than half the sheet is occupied by a dense forest. The twisted tree-trunks dissolving into a tangle of branches above and the flickering shadows among the leaves reflect the style of the Venetian artist Girolamo Muziano, who had been in Rome since 1548. This drawing perhaps gives some idea of Bruegel's study of a tree painted on linen, already mentioned as given to Clovio. It must certainly have been admired by Hieronymus Cock, since the latter adapted it for his etching *The Temptation of Christ*. The *Forest Landscape with Bears* and related studies reveal Bruegel's versatility as a landscapist, but at the moment the artist was more interested in mountain scenes, and it was probably in 1554 that he left Rome to tour the Alps.

30

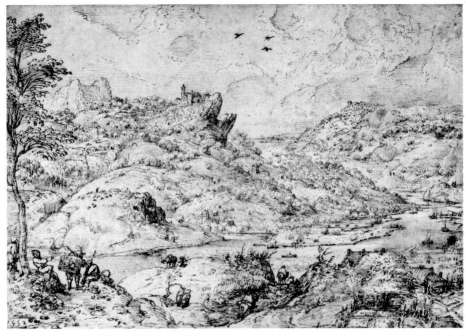

9 *Landscape with River and Mountains* 1553

10 *Forest Landscape with Bears* 1554

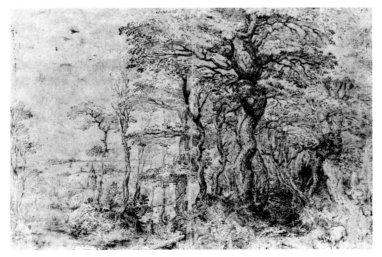

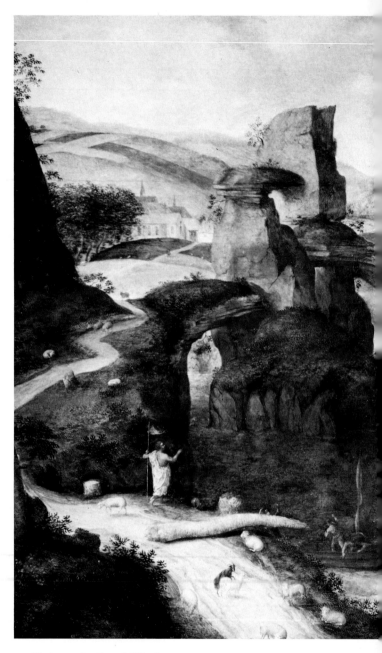

11 *Christ on the Sea of Tiberias* 1553

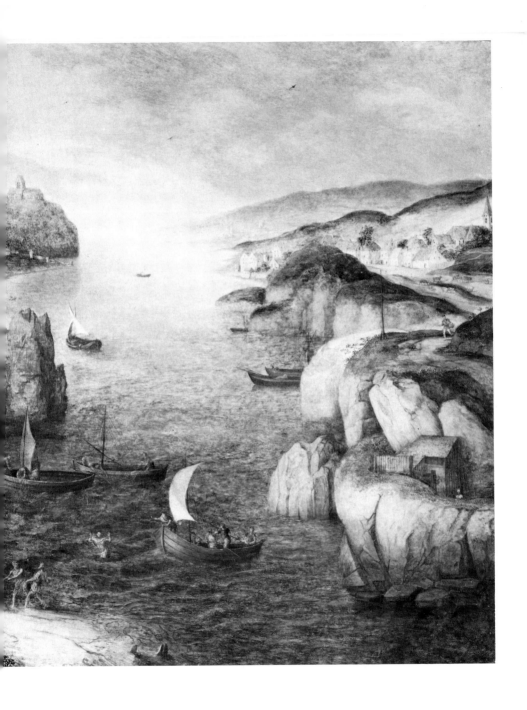

In the Middle Ages, the Alps were regarded chiefly as obstacles to travel, abodes of devils, and blemishes deposited on the earth by the Flood. By Bruegel's day, however, this traditional fear of mountains was beginning to give way to a profound interest, in which admiration was mixed with awe. In 1541, the Swiss physician Conrad Gesner could exclaim: 'What greater delight for the soul justly touched than to admire the spectacle offered by the enormous mass of these mountains . . . without being able to explain it, I sense my spirit struck by their astonishing heights, and ravished in the contemplation of the sovereign architect.' Many of the great Alpine peaks were scaled for the first time in this century, and descriptions of the Alps appeared in great numbers, culminating in Josiah Simler's majestic *De Alpibus* (*On the Alps*), published in Zürich in 1570 and the first treatise devoted exclusively to the subject.

That Bruegel was fired by a similar enthusiasm for mountainous scenery is demonstrated by the circuitous route of his Alpine tour. He travelled through the Ticino Valley and northward through the St Gotthard Pass. The watershed for all of Europe, the St Gotthard massif was erroneously thought in the sixteenth century to contain the highest peaks in the Alps. 12 Bruegel also saw the Waltensburg on the Vorder Rhine, some miles north-east of St Gotthard, and perhaps the Martinswald near Innsbruck. These places have been identified from various drawings surviving from his trip, and from a lost picture once owned by Rubens.

Generally, however, Bruegel was not primarily concerned with making topographically accurate records of his journey. In fact, relatively few drawings fall into this category. In the 13 *Landscape with Range of Mountains*, for example, the absence of the usual compositional devices suggests that this was a direct transcription from nature, as do the unfinished areas at the bottom. Bruegel apparently focused on the middle distance, ignoring the scenery closer at hand. In other drawings Bruegel reworked his impressions into more finished compositions. This may be true of the *View of Waltensburg*, which several

34

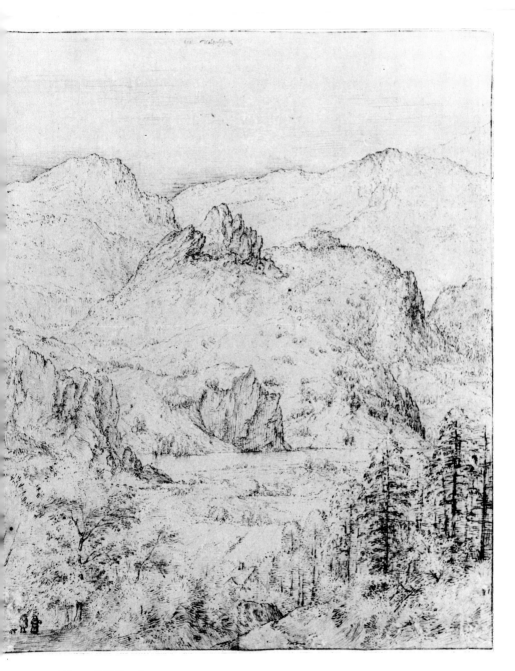

12 *View of Waltensburg, c.* 1553–4

scholars believe to have been executed later from memory, or from sketches done on the spot.

But whether composed later or done directly after nature, Bruegel's Alpine drawings were all executed with a pen in brown ink, sometimes in several shades. They display nothing of the brilliant calligraphical style with which similar views were depicted by Albrecht Altdorfer and other draughtsmen of the Danube School, nor do they show the elegantly decorative line found in the landscape-drawings of Matthys and Hieronymus Cock. Bruegel was more soberly objective and analytical, employing different techniques to represent the variety of shapes and textures in nature. A system of hatching and cross-hatching renders the sharp and multi-faceted surfaces of rocks and cliffs; short strokes and dots capture both the bulk and the leafy texture of trees. Chiefly through the patient accumulation of these and other details, Bruegel was able to convey the great magnitude of the Alps. In the *Landscape with Range of Mountains* the scale of the mountains is established by the diminutive trees which cluster at their feet, or cling to their steep flanks. In the *View of Waltensburg* the Vorder Rhine dwindles to an insignificant stream in comparison to the mountains rising directly from its banks. These mountains, in turn, are dwarfed by the peaks behind, and the presence of even more dizzying heights is implied by the slope rising beyond the picture's edge at upper right.

The significance of Bruegel's Alpine experience was appreciated by his biographer Van Mander, who tells us that during his trip, Bruegel 'swallowed all the mountains and rocks and spat them out again, after his return, on to his canvases and panels'. If we include the drawings, this colourful observation may be accepted as essentially correct, although Bruegel's transformation of nature into art was more complicated than Van Mander suggests. This can be seen in one of the first results 14, 15 of Bruegel's travels, the so-called *Large Landscapes*, a set of twelve prints which Cock published after Bruegel's designs. Three of Bruegel's preliminary drawings have survived, one of

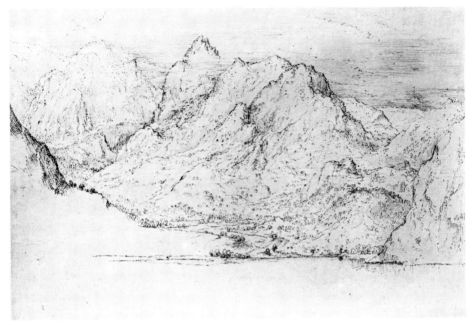

13 *Landscape with Range of Mountains, c.* 1554–5

them, *Mountain Ravine* (Paris, Louvre), dated 1555. Bruegel must have begun working on the *Large Landscapes* soon after his return to Antwerp. Ten of them represent mountainous scenes, but while Bruegel incorporated details sketched on his Alpine trip, his compositions are clearly indebted to earlier Flemish landscape-painting.

This traditional element has puzzled some critics who assume that Bruegel was constrained by Hieronymus Cock to cater to public taste. However this may be, it is evident that he was not limited by the old formulas of Patinir and Bles; on the contrary, he revelled in them, creating landscapes of a rugged grandeur never dreamed of by his predecessors. This is evident, for example, in the *St Jerome in the Wilderness.* From the grove of 14 trees in the right foreground sheltering the praying saint, it is almost a sheer drop to the little valley beneath, where tiny deer graze, and from which further precipitous descents bring the

viewer to the water below. The broad expanse of river plain and sea at the left revives the panoramas of Patinir, but the older artist seldom organized his ground planes so logically, nor did he ever represent a cliff as imposing as the massive outcropping which fills up the right side of the *St Jerome*.

Even more original among the *Large Landscapes* is the *Alpine* 15 *Landscape with Deep Valley*. Here we are transported into the very heart of the Alps, looking down upon a deep cleft between two mountain ranges, the peaks at the right obscured by clouds. The steep slopes are traversed by narrow, boulder-strewn paths, and the tiny figures trudging along them vividly convey the hardships of Alpine travel. The contemplation of these precipitous footpaths, often with a sheer drop on one side, would have aroused a vicarious thrill in contemporary viewers, even those who would have regarded the actual prospect with vertigo and horror. Few of Bruegel's earlier Alpine scenes create the same visceral effect.

It is generally assumed that these and the other prints in the *Large Landscape* series were executed by Hieronymus Cock himself, employing a combination of etching and engraving. 18 To judge from the surviving preparatory drawings, Cock followed Bruegel's original designs fairly closely, only occasionally adding details. In visual effect, however, the prints are quite different from the drawings. The delicate, discontinuous contours made by Bruegel's pen were hardened, his diffuse shapes were transformed into compact, crisply modelled forms, and his atmospheric perspective disappeared, permitting even the most distant details to be seen with telescopic clarity. Thus transformed, Bruegel's *Large Landscapes* have much in common with the maps published by Cock and Ortelius.

The two landscape-paintings done by Bruegel during the second half of the 1550s, the *Fall of Icarus* and the *Parable of the Sower*, are compositionally related to the *Large Landscapes*. The *Fall of Icarus* exists in two versions, of which the one in the 16, 17 Musées Royaux des Beaux-Arts, Brussels, was probably done by Bruegel himself, about 1555–8. A recent laboratory

38

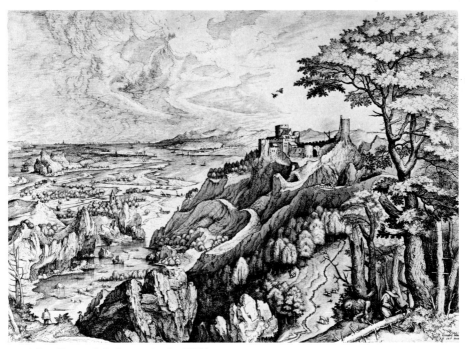

14 After Bruegel *St Jerome in the Wilderness, c.* 1555–60

15 After Bruegel *Alpine Landscape with Deep Valley, c.* 1555–60

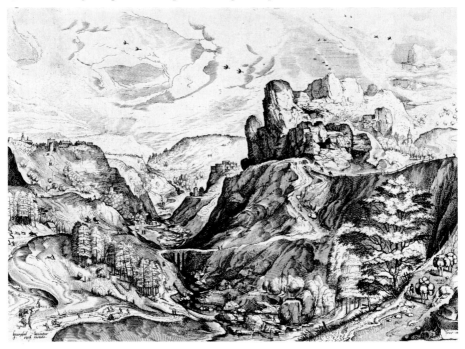

examination reveals that this picture was originally painted on canvas (not on wood, as formerly believed) and has suffered from repairs and overpainting, although these have failed to obscure the imposing composition. In the foreground at the left a farmer ploughs a narrow strip of land; the mountainous coast beyond descends by several levels past a shepherd and his flock to a placid blue-green sea. Coastal towns, islands and shimmering white rocks appear to float magically on the water's surface. This is one of Bruegel's most idyllic landscapes, seemingly without dramatic incident – until we notice the legs of a figure disappearing beneath the water near the fisherman seated at lower right. This is Icarus, who escaped with his father Daedalus from prison on wings made of feathers fastened with wax. His wings are melted by the heat when he disobeys Daedalus's command and flies to close to the sun, and he plunges to his death by drowning.

This ancient myth was well known to the Renaissance through the *Metamorphoses* of Ovid. Describing the flight of Daedalus and his son, Ovid writes that 'some fisher, perhaps, plying his quivering rod, some shepherd leaning on his staff, or a peasant bent over his plough handle caught sight of them as they flew past and stood stock still in astonishment, believing that these creatures who could fly through the air must be gods'. Bruegel depicts the three witnesses to the flight, and the soft, calm Southern waters may well be inspired by Ovid's description of the Aegean Sea into which Icarus fell. But he deviates from Ovid's text by showing his ploughman apparently oblivious to Icarus's fate. Other iconographical anomalies – the absence of Daedalus and the displacement of the sun from overhead to the distant horizon – are perhaps less due to Bruegel's innovations, as sometimes thought, than to changes made by subsequent overpaintings. The only mythological subject ever painted by Bruegel, the fall of Icarus was commonly understood during this period as a parable of the fate of those who foolishly aspire to rise above their rank in life. Bruegel may well have intended to convey a similar moral lesson.

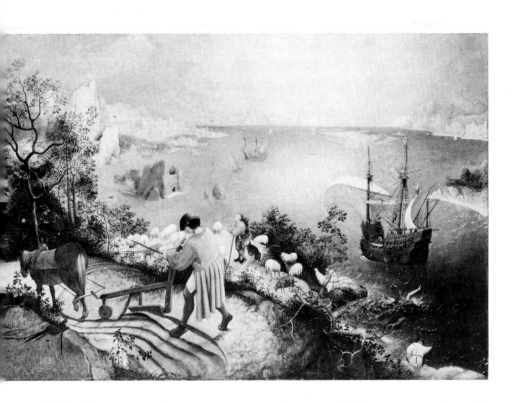

16 *Fall of Icarus, c.* 1555–8

17 Icarus vanishes
unnoticed into the sea
(detail of 16)

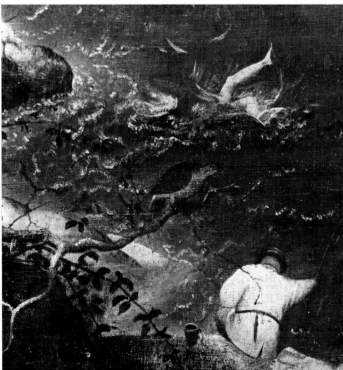

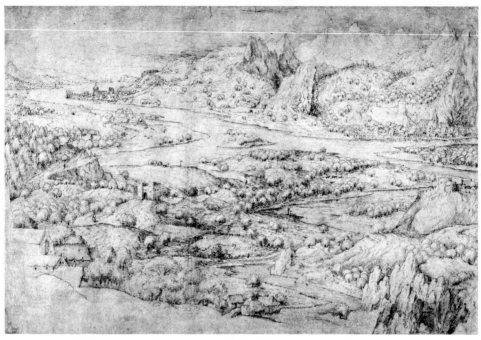

18 Preparatory drawing for *Solicitudo Rustica* engraving, *c.* 1555

Signed and dated 1557, the other landscape represents the
parable of the Sower as recounted in Matthew 13:3–23. The
sower strides across a field at lower left, scattering seed upon the
various kinds of soil described in the text. On the right, Christ
stands in a boat preaching the parable to his audience gathered
on the shore. As Stechow has observed, the composition
exhibits many similarities to one of the *Large Landscapes* series,
the *Solicitudo Rustica*, especially in the diagonal movement of
the river into space. In the distance are great mountains, their
lofty peaks thrusting up against an ominous sky. These are
among the most awesome mountains Bruegel ever painted,
terrifying in their stupendous size and their remoteness from the
ordinary world of man. They dwarf the hills in Bles's landscapes
and make those in Patinir's pictures seem hardly more than
rocky fantasies.

42

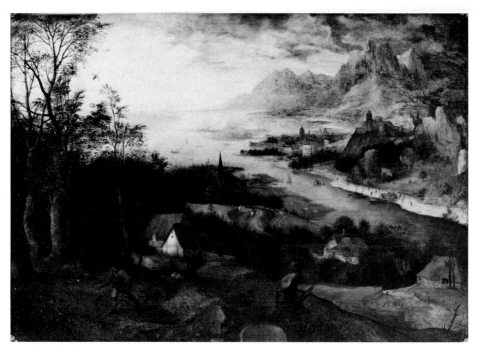

19 *Parable of the Sower* 1557

A comparison of the *Parable of the Sower* with the *Christ on the Sea of Tiberias* reveals how much Bruegel had matured as a landscapist between 1553 and 1557. The earlier painting, presumably done before his tour of the Alps, is a rather tame reworking of the conventional forms of Flemish landscape-painting. In the *Parable of the Sower* Bruegel radically transformed these conventions in the light of his Alpine experiences, and thereby created a landscape of incomparable majesty. The traditions of Patinir and Bles would continue to inspire Bruegel, as can be seen in his *Flight to Egypt* of 1563 (London, Collection of Count Antoine von Seilern) owned by Cardinal Granvella, and in the imposing *Labours of the Months* of 1565. In the meantime, however, he had also begun to explore territory even stranger than the Alps – the infernal landscapes of Hieronymus Bosch.

43

A second Hieronymus Bosch

When Hieronymus Bosch died in 's-Hertogenbosch in 1516, the accounts of the Brotherhood of Our Lady, of which he was a member, referred to him simply as 'Jeronimus van Aken, painter'. When these records were copied about 1567, this entry was amended to read 'Jheronimus van Aken, alias Bosch, distinguished painter'. The addition of the adjective 'distinguished' attests to the great fame which Bosch had achieved in Europe during the half-century after his death. His compositions were copied in great numbers and his style was imitated by a host of minor artists, mostly anonymous, who supplied the public with little paintings containing swarms of devils and picturesque fiery effects. A new phase in Bosch's popularity, however, seems to have begun in the 1540s with the appearance of major pictures in his style by Jan Mandyn and Pieter Huys, both working in Antwerp, and, probably sometime during the next decade, Cardinal Granvella commissioned four tapestries after Bosch's works, including the *Garden of Earthly Delights* and the *Haywain*.

The public interest in Bosch after mid-century undoubtedly owed much to the efforts of Hieronymus Cock. From the shop of the Four Winds came numerous engravings which depicted such subjects as the *Blue Ship*, the *Stone of Folly* and the *Battle for the Elephant*. Most of them bear Bosch's name as inventor, although how often they reflect authentic works, now lost, is uncertain. Bruegel's contribution to this enterprise must have begun fairly soon after his return to Antwerp. By 1556 he had produced several drawings in the style of Bosch. One of these is the *Big Fish Eat the Little Fish*, which Cock published the

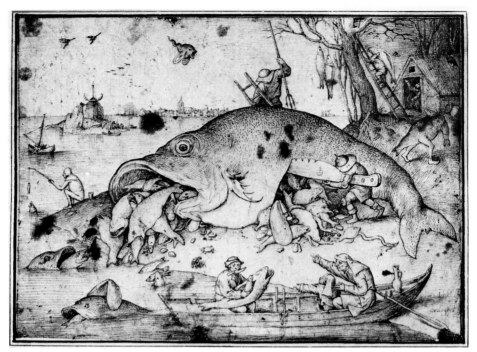

20 *Big Fish Eat the Little Fish* 1556

20

following year as an original design by Bosch. His reasons for omitting Bruegel's name are unclear; perhaps he wished to capitalize on the reputation of the older artist.

In any case, Bruegel's other drawings of 1556 were published as engravings under his own name. These include the *Allegory of Avarice*, the first sheet in the *Seven Deadly Vices* series completed in 1557. Most of them carry inscriptions which were probably added by another hand, as was true of other designs which Bruegel executed for Cock. The *Seven Deadly Vices* clearly show how Bruegel responded to Bosch's fantastic imagery. Each composition is dominated by the Vice personified by a female figure; in gender and attributes, the Vices conform to traditional iconography. Surrounding each is a hellish landscape where further examples of the sin and its consequences are displayed.

Bruegel's allegorical method is well exemplified in the
21 *Allegory of Lust*. This vice is personified by a nude woman who
caresses her demon lover; a second devil offers them a carafe on
a tray. These figures and the rotting tree-trunk sheltering them
parody the love-pavilions frequently depicted in fifteenth- and
sixteenth-century art; Bosch drew upon this same imagery to
symbolize Lust in the *Tabletop of the Seven Deadly Sins* (Madrid,
Prado). Bruegel's tree is crowned by a great mussel-shell
enclosing a naked couple in a transparent bubble, a conflation of
two motifs from the central panel of Bosch's *Garden of Earthly
Delights*. Below appears a branch resembling the head and
antlers of a stag, traditional symbol of uncontrolled sexual
passion. The significance of the central group is repeated in
various ways throughout the composition. Two dogs mate by
the fence at left, unaware of the monster about to attack them
from behind. Near by a demon castrates himself, while before
the entrance of the tree an obscene little creature douses himself
with egg, regarded in Bruegel's day as an aphrodisiac. In the
right middleground, some devils escort two nude victims; a
third naked figure rides a skeleton monster which Bruegel
22 adapted from the central panel of Bosch's *St Anthony* triptych.
This third victim wears a head-dress resembling a bishop's
mitre, a detail which Cock's engravers prudently altered to a
less distinctive shape, in order to avoid ecclesiastic censure. This
procession is led by a man playing a bagpipe, whose erotic
connotations were well known in the sixteenth century.

A love garden can be seen in the background, where amorous
couples frolic on the grass and bathe in the basin of a Gothic
fountain. Another couple embraces within a leafy bower. In
contrast to this idyllic scene is the pavilion at the left, where a
crowd of hapless nudes is attacked by a sea-serpent.

Of all the *Seven Deadly Vices*, the *Allegory of Lust* was the one
most heavily indebted to Bosch. Occasional borrowings from
the older master are encountered in the other drawings of this
series, but Bruegel, like some of his predecessors, generally
manipulated Bosch's formal vocabulary with greater freedom.

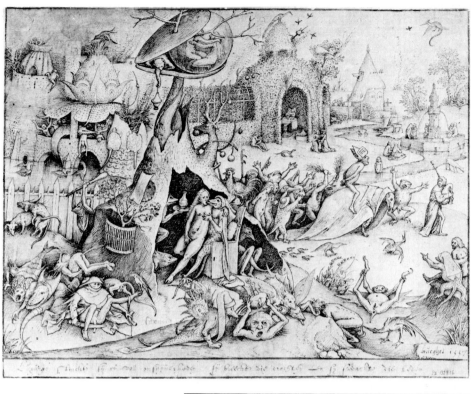

THE SEVEN DEADLY VICES
(pls. 21, 23–4)

21 *Allegory of Lust* 1557

22 Hieronymus Bosch *The
Temptation of St Anthony
(detail)*

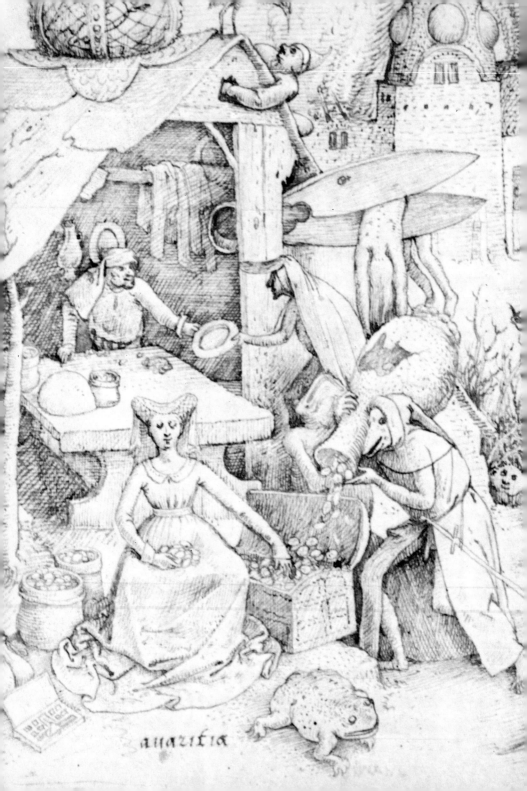

auaricia

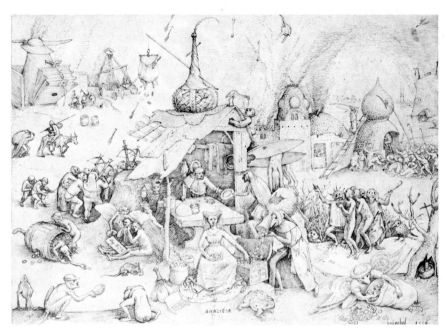

24 *Allegory of Avarice* 1556

Not every detail in the *Seven Deadly Vices* can be understood by the modern viewer. We still do not understand, for example, the significance of the boots and shoes which appear repeatedly in the *Allegory of Envy*. But in most instances, the basic subject is clear. In the *Allegory of Avarice* the personified Vice sits amid her money-bags and chests; behind her is a pawnshop whose signboard is an oversized pair of shears from which dangles a nude figure. This illustrates the saying 'there hangs the shears', originally said of tailors who cheated when measuring cloth, but later applied to any shop or tavern which defrauded its customers. The theme of avarice is further developed in the landscape, where, among other scenes, a company of archers at left takes aim at a huge purse, unaware that their own purses are being stolen. In the right distance, a greedy mob storms a large savings-pot. The grotesque increase in scale of purses, pots and other common objects is a device which Bruegel could have studied in the *Hell* wing of the *Garden of Earthly Delights*.

23

24

49

◁ 23 Avarice (detail of 24)

In *Anger*, the chief Vice and her army emerge wrathfully from a tent into a smoking world ruled by violence and war. Enthroned on her main attribute, the pig, the Vice in *Gluttony* plays hostess to a banquet of gluttons and guzzlers. In *Sloth*, the Vice and her companions are sunk in sleep, oblivious to the warnings of the bell-ringer and the animated clock that time is running out. Snails and slugs well symbolize their indolence, as does the man the middleground too lazy to relieve his bowels without assistance.

Such humorous touches as this last detail can also be found in the *Allegory of Pride*. Accompanied by her attribute, the peacock, Pride admires her magnificent gown and jewels in a mirror, unaware that her ill-fitting undergarment trails on the ground behind her. Her haughty demeanour is mocked by the frog-faced creature grinning at us from behind her skirt; her conceit finds its counterpart in two monsters with mirrors at lower right, one admiring his posterior, the other gazing fatuously at the ring piercing his lips. Like the mirror, the peacock feather appears again in unlikely contexts. It forms the chief adornment of the animated egg at lower left, and completes the tail of the demon with the lip-ring and his mermaid companion. Pride's attendants include a bizarre figure encased to the chin in a conical gown and an armed devil whose shield appropriately bears a pair of tailor's shears. At the left is a barber's establishment. On the roof, a nude man defecates into a dish placed suspiciously close to the mortar and pestle standing on a lower level. If this is source of the liquid with which the two attendants wash the hair of the woman below, it would be hardly worse than the concoctions which, according to contemporary satirists, were employed by fashionable ladies to preserve and improve their beauty.

Another characteristic of Pride, the love of vain show, is surely symbolized in the ornate cupolas surmounting the barber's shop and the buildings in the right background. In the centre, allusions to pride of rank can be discerned in the ship-like structure; here, a crowd of naked people pays homage to a

man wearing only an oversized helmet that conceals his head. The owlish monster close by wears a crown whose four stages surpass the triple form of the papal tiara. At the far left, a devil capers on top of a high cliff, unique in the landscapes of the *Vices*, and possibly a reference to those who strive for an exalted station in life: 'the higher the mountain, the deeper the fall,' according to a contemporary proverb.

The *Pride* and the other sheets in the series reveal that Bruegel shared with Bosch a predilection for transforming proverbs and sayings into striking visual images, and for startling juxtapositions of form. Their differences, however, are more important than their similarities. Although more sophisticated than most of Bosch's followers, including Mandyn and Huys, Bruegel never achieved the complexity of form and meaning that we find in the two works by Bosch which he seems to have known best. With few exceptions, the symbolism of the *Vices* is less recondite than that of the *Garden of Earthly Delights*; their hybrid monsters are simpler, more earthy and material, with little of the subtle metamorphosis of shape which dazzles the viewer of the *St Anthony* triptych. Above all, there are few 22 counterparts in Bosch's mature work to the humorous, whimsical elements which pervade such Bruegel drawings as the *Sloth* and *Pride*.

If Bruegel's infernal landscapes fail to grip us with the same intensity as Bosch's Hell scenes, this is not merely because his technique of pen and ink offered fewer resources than Bosch had at his command in his paintings; it is also because devils no longer possessed the same reality as they had in Bosch's day. Erasmus had laughed at devils, calling them mere spooks and bogey-men; and the vices and devils who appear in the *rederijker* allegories are usually more comical than terrifying, perpetually frustrated in their attempts to ensnare human souls. Sin was caused less by the machinations of devils than by the misuse of human reason—a typically humanist diagnosis of the cause of evil and one which appealed widely to the secular society of the period.

25 (overleaf) Allegory of Pride 1557

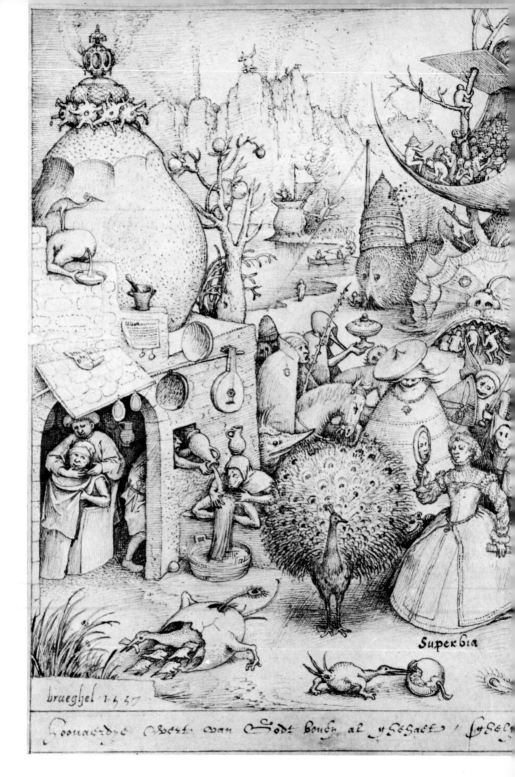

Superbia

brueghel 1557

Hoouaerdye vbert van godt bouen al yghaet / fghel

set godt weder coan goomerdge codesmaet

The enterprising middle classes of the sixteenth-century Netherlands firmly believed in the dignity and virtue of their way of life. In the Antwerp *Landjuweel* of 1561, each *rederijker* chamber presented a prologue in praise of merchants, a subject that must have been congenial to both actors and audience. For as one chamber insisted, honest profit was good as long as it was governed by reason. But Bruegel's countrymen were also acutely aware of the moral dangers inherent in a worldly, commercial society, particularly greed and *eigenbaat*, or selfishness. These sins were often condemned in *rederijker* dramas and pageants. Bruegel had treated them in his *Big Fish Eat the Little Fish*, and it is perhaps significant that he began his *Seven Deadly Vices* with the *Allegory of Avarice*. In the annual procession held in Antwerp in 1563 to celebrate the Feast of the Assumption, a series of didactic tableaux were included that castigated the greed and self-seeking of Elck (literally Each or Everyone), comparable to Everyman in the English morality of that name.

26 Elck's frailties, however, had already been depicted by Bruegel in a drawing of 1558. In the foreground, Elck appears several times as an elderly, near-sighted man searching through a jumble of barrels and bales, various tools, a chess-board, playing-cards and other objects These represent the goods and distractions of the world, and their intrinsic worthlessness is clearly conveyed by the imperial orb, a traditional symbol of vanity, which lies broken at the feet of the central figure. Two men at upper right tug vigorously at a strip of cloth, while in the left background Elck can be seen again, seeking with his lantern near a military encampment and trudging towards a church. As we learn from the inscription added by Hieronymus Cock to the engraved version of this composition, this elaborate charade expresses two proverbial sayings, 'Elck seeks himself in the world', and 'Elck tugs for the longest end', both allusions to selfishness and greed.

The cause of Elck's spiritual blindness is suggested in the picture on the wall at upper right: a fool gazes at his reflection in

26 *Elck* ('Everyone') 1558

a mirror amid a pile of broken household utensils. He is Nemo, or Nobody, a popular figure in contemporary folklore, and the significance of his action is explained by the inscription below: 'Nobody knows himself'. In the procession of 1563 just mentioned, one of the floats illustrated the verse, 'Elck seeks himself and comes to grief because he cannot judge himself clearly.' Bruegel's picture within a picture conveys the same idea by punning on the name of Nemo, but it also implies the remedy for Elck's predicament. This is the Socratic injunction 'Know thyself', which in the *Handbook of the Christian Knight*, Erasmus had acclaimed as the crown of God-given knowledge.

As a trenchant criticism of contemporary society, Bruegel's drawing undoubtedly influenced the Elck pageant mounted

some five years later. Stylistically, the *Elck* represents a significant step in his artistic development. In comparison with his earliest drawing with large-scale figures, the *Ass in School* of 1556, it is more carefully composed, dominated by a diagonal movement established by the foreground figures. The modelling of the figures is more confident, with a greater concern for three-dimensional volumes. These same qualities also appear in a second drawing of 1558, the *Alchemist*, which presents another aspect of human folly.

27

The *Alchemist* introduces us to a dilapidated laboratory; at lower right a man sits before a hearth amid a litter of vials, retorts and smoking vessels. Alchemists were identified in the popular mind with attempts to transmute base metals into gold, and the failure of Bruegel's alchemist in this endeavour is attested to by his tattered clothing and by his wife who pointedly displays her empty purse to the viewer. Likewise, one of the children playing at the back of the room wears a cooking-pot on his head, a clear sign that it has no other function in this destitute household. Bruegel's skill in rendering the human face in its droller aspects is superbly displayed in the witless grin of the alchemist's wife and in the distorted features of the fool kneeling near by, furiously pumping the bellows on a charcoal brazier. These futile operations are directed, it seems, by the scholarly man seated at left. On his reading-desk rests an open book in which he points to the words: 'Alghe-mist', a pun on *alchemist* and *al-ghemist*, Netherlandish for 'all is lost'.

These words aptly reflect the low esteem in which alchemy was held during the fifteenth and sixteenth centuries. Many stories circulated about alchemists who fleeced their patrons with fraudulent claims to make gold. As Matthias Winner has suggested, the man at the left may represent such a deceiver; both he and the fool seem to have escaped the fate of the second alchemist and his family. Through a large opening in the back wall we see them once more, seeking refuge in a poorhouse.

This last detail was probably inspired by the French satire, *The Right Way to the Almshouse*, which was widely imitated

56

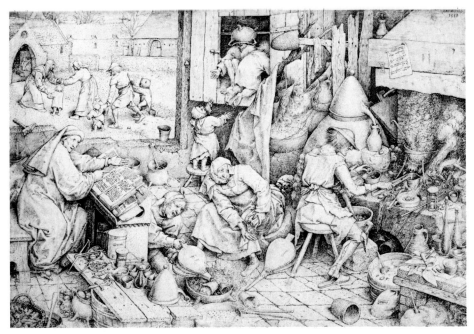

27 *The Alchemist* 1558

during the sixteenth century. In a Netherlandish version written about 1550, we are told that the way to the almshouse is crowded with gamblers, drunkards, lazy housekeepers and others ruined by their own folly. Although the alchemist is not mentioned by name, contemporary opinion would undoubtedly have numbered him among these improvidents.

Moralizing subjects like that depicted in the *Alchemist* enjoyed great popularity in Bruegel's day. Hieronymus Cock published several prints depicting ill-regulated shops and households, possibly designed by the Malines artist Jan Verbeeck. One of Cock's competitors in Antwerp, Bartholomeus de Mompere, issued an etching satirizing the shoemaker impoverished by a family too large to support; his kind also appears among the throngs going to the poorhouse. If avarice and self-seeking were considered major evils of the day, so were the opposite extremes of prodigality and poor financial

management. 'A man without money is a corpse', we are reminded by a contemporary proverb.

The same middle-class values are celebrated in the drawings the *Seven Virtues* which Bruegel prepared for Cock's engravers in 1559–60. Probably planned as a sequel to the *Seven Deadly Vices*, the *Virtues* resemble them in composition. Each Virtue, personified by a female figure, occupies the centre, surrounded by scenes illustrating its various manifestations. In contrast to the *Vices*, however, the influence of Bosch's demonic imagery appears only in the *Allegory of Fortitude*, where men and women battle with Seven Deadly Vices symbolized by beasts and devils. In the other *Virtues*, Bruegel drew his illustrative examples from the everyday world. A precedent for this mode of presentation occurs in a woodcut executed in 1545 by the German artist 28 Heinrich Vogtherr, in which Hope stands in a landscape filled with genre-like incidents.

While Bruegel may have known Vogtherr's woodcut, his 29 own *Allegory of Hope* was infinitely richer, in both composition and subject-matter. The personified Virtue stands on her anchor in the midst of a raging sea. Ships are engulfed by huge waves and attacked by monstrous fish; the survivors pray for help and attempt to swim to safety. In the fortress at lower right, prisoners sit in irons or the stocks; through the window-grate above, other prisoners let down a bottle on a string, perhaps in hopes of obtaining fresh rainwater. Despite their relatively small scale, the foreground scenes are rendered in a sprightly style which animates each detail: the lashing of the waves against the wharf, the fear and terror of the sailors, and the dejection of the prisoners. Other kinds of hope are depicted on the wharf and embankment beyond. A woman, possibly pregnant, clasps her hands in prayer; a man inspects his three fishing-rods for a catch. Another man kneels before an open-air shrine, and behind him a crowd of people strives to save a burning house. In the distance, farmers work in the fields.

The hopes thus represented are directed toward practical ends: hope for material gain, hope for delivery from prison or

from physical danger. Absent are specifically Christian objectives, such as the hope for victory over sin and for eternal salvation. De Tolnay and other scholars have argued that by omitting references to these more spiritual concerns, Bruegel meant to demonstrate the vanity and futility of most human hopes. This opinion, however, seems unwarranted. To a large extent, Bruegel was simply elaborating ideas already inherent in the attributes associated with Hope since the later fifteenth century, many of which are included in his drawing. Hope's spade and sickle allude to hopes for a good harvest, the beehive balanced on her head symbolizes the hope for human prosperity in general. The sea-storm, moreover, alludes to another object traditionally connected with Hope, the ship, which Bruegel omitted as an attribute but which was included by Vogtherr. Indeed, the conventional nature of Bruegel's interpretation of this virtue is clearly demonstrated by the long poem accompanying Vogtherr's woodcut; it is almost exclusively concerned with desires for success and happiness in temporal affairs, many of which were represented by Bruegel.

28 Heinrich Vogtherr the Elder *Allegory of Hope* 1545

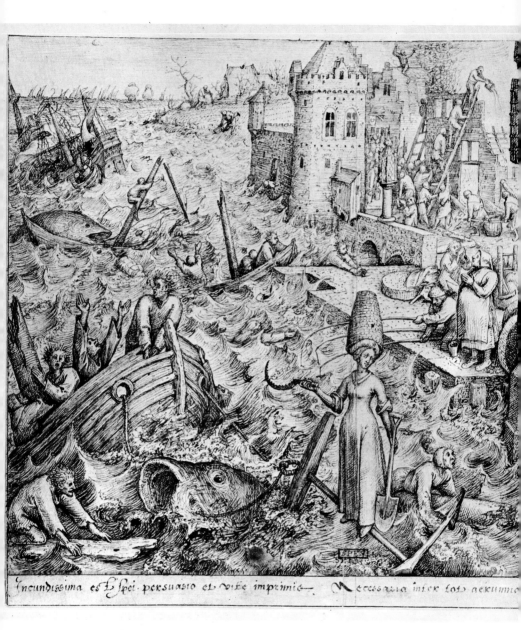

Incundissima est Spei persuasio et vite imprimis— Necessaria inter tot aerumnas

THE SEVEN VIRTUES
(pls. 29–34)

29 *Allegory of Hope* 1559

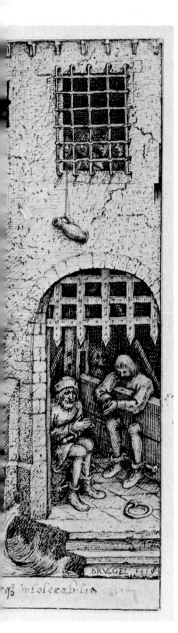

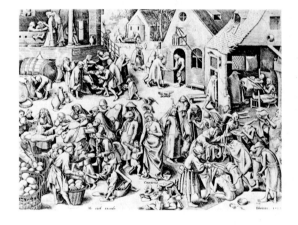

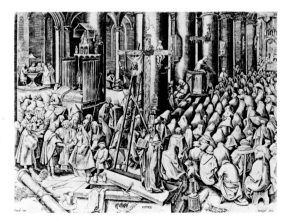

30 *Allegory of Justice, c.* 1559

31 *Allegory of Charity* 1559

32 *Allegory of Faith, c.* 1559

Similar objections may be raised against the claim that the other *Virtue* drawings represent perversions of the qualities they purportedly illustrate. As in the *Allegory of Hope*, it is more likely that Bruegel was demonstrating the relevance of the virtues to everyday life, as it was understood in his day. Thus

30 *Justice* is accompanied by scenes of torture and punishment; if these incidents seem unduly harsh to us, they were accepted by Bruegel's contemporaries as necessary to maintain public law and order. This attitude is expressed in several Flemish legal treatises of the period, and in a print after Maerten van Heemskerck, depicting the ideal king, the beheading of a prisoner was included as an attribute of royal justice. In the

31 *Allegory of Charity* Bruegel represented the Seven Acts of Mercy, those charitable actions for which the merchants were commended in one of the prologues presented at the Antwerp

32 *Landjuweel* of 1561. *Faith* is placed in a church where a congregation has gathered to receive the sacraments and hear

33 the word of God. *Temperance* is shown as the virtue governing the Seven Liberal Arts and these in turn are illustrated by representatives of the various crafts and professions, including bankers, painters and *rederijkers*, who contributed to the prosperity and glory of Antwerp.

34 *Prudence* is exemplified by the prudent conduct of ordinary life. The allegorical figure holds a coffin in one hand, in the other a mirror, in this case a symbol not of vanity, but of self-knowledge. The sieve on her head signifies the ability to separate wheat from chaff, right from wrong. The ladders and other fire-fighting equipment at her feet may represent Bruegel's original additions to the traditional attributes of Prudence, but their appropriateness would not have been questioned by a society constantly endangered by fire: Antwerp was devasted by several conflagrations during the sixteenth century, the worst one occurring in 1541. Many of Prudence's followers are occupied with household affairs; they butcher animals and preserve the meat; they store hay and repair a house. One man in the centre secures his money in a strong

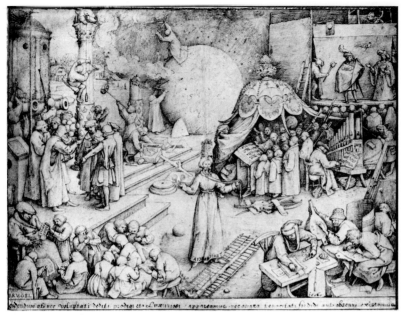

33 *Allegory of Temperance* 1560

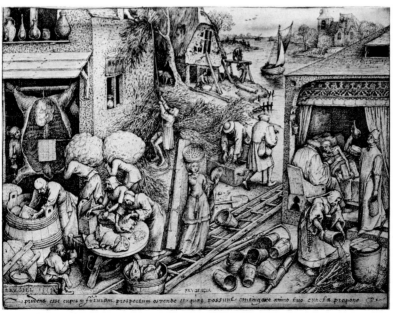

34 *Allegory of Prudence* 1559

chest, his gesture imitated by the child at lower left who puts a coin into his purse. At right, a woman prudently douses some smouldering twigs; near by, an invalid consults both priest and physician while preparing his will. In all its details, Bruegel's *Allegory of Prudence* is the very antithesis of his *Alchemist*, and there is no doubt that it would have been understood as such by the merchants and shopkeepers who purchased engravings of these subjects at the shop of the Four Winds.

Bruegel designed other moralizing subjects for Cock's engravers, including the *Battle of the Money-Chests and Savings-Pots*, the *Sleeping Peddlar Robbed by Monkeys*, and the *Feast of Fools*. Together with the *Vices* and *Virtues*, *Elck* and the *Alchemist*, these works established Bruegel's reputation with the general public. In his lifetime he was acclaimed by Guicciardini as the 'second Hieronymus Bosch', a sentiment echoed in Domenicus Lampsonius's poem inscribed on the engraved portrait of Bruegel published in 1572. As we have seen, however, such praise ignores the important differences which existed between Bruegel and Bosch. The humour and worldly wisdom which pervades many of Bruegel's moralizing drawings were generally alien to the older master. It was Bruegel's merit, in fact, to transform Bosch's rich artistic heritage into images that reflected the new concerns and ideals of his own age.

The theatre of the world

Proverbs and figures of speech were frequently illustrated in the drawings which Bruegel made for Hieronymus Cock. One of his earliest figure compositions, as we have seen, depicted the saying, 'the big fish eat the little fish', while similar proverbs appear in *Elck* and in at least several sheets of the *Seven Deadly Vices*. Nowadays we may perhaps regard proverbs as mere commonplaces, remnants of a homespun wisdom having little relevance in modern society, but in Bruegel's day they played a vital role in speech and writing.

From ancient times on, proverbs were appreciated as expressions of universal truths, and their often cryptic or metaphorical forms only enhanced their wide appeal. The Bible contains many proverbs, Christ quoted them, and the Greeks and Romans employed them to clinch an argument or embellish an oration. This distinguished ancestry ensured the continued use of proverbs throughout the Middle Ages, but their popularity seems to have reached its height during the sixteenth century. Luther and Erasmus made copious use of proverbs; Rabelais often heaped up whole paragraphs of old saws for comic effect in his *Gargantua and Pantagruel*, and in 1547, to cite but one more example, the English dramatist John Heywood composed a long poem with a title which began: 'A Dialogue containing in effect the number of all the Proverbs in the English Tongue. . . .'

This enthusiasm for proverbs is also manifested in the many collections of them published during the sixteenth century. The most famous was the *Adages* of Erasmus, a compilation of Greek and Latin proverbs with extensive commentaries which went

through many revisions and expansions after the first edition of 1500. The earliest collection of Netherlandish proverbs was published in Antwerp in 1549. Between this date and Bruegel's death in 1569 at least five such collections appeared in the Netherlands, including François Goedthals' *Old French and Flemish Proverbs* published by Christopher Plantin in 1568.

The transformation of proverbs into visual images was also a venerable practice. Long before they had inspired Bosch's enigmatic forms, proverbs had been illustrated on the margins of illuminated manuscripts, and were often carved on choir-stalls. In the sixteenth century they appear in German and Netherlandish woodcuts, occasionally accompanied by long moralizing poems. Bruegel's use of proverbs, therefore, reflects a common taste of his time, and his interest in them can be seen as late as the *Parable of the Blind*, painted in 1568. Another example is the so-called *Twelve Proverbs* (Antwerp, Museum Mayer van den Bergh), which he seems to have executed as a set of wooden plates, probably in the 1560s; only later were they inserted into their present frame. But certainly his most
44 encyclopaedic representation was the *Netherlandish Proverbs* (also called *The Blue Cloak*) of 1559.

Fairly large in size, this picture shows a village whose inhabitants act out a whole catalogue of old adages and expressions, so many, in fact, that only a few of them can be described here. Within the stable at lower left, one man literally 'falls between two stools' (to fail, through hesitation or indecision, to choose one of two alternatives). In the courtyard
36 outside, a woman 'carries fire in one hand and water in the
35 other' (she dissimulates); near by is a 'pillar-biter' or hypocrite,
38 while the housewife tying the devil to a cushion represents an unpleasant type we will meet again in Bruegel's *Dulle Griet*.
37 Passing from the man who 'butts his head against the wall', and his companion who is not only 'armed to the teeth', but tries to
39 'bell the cat', we encounter a man filling in a hole after his calf has been drowned. Above him appears the adulterous wife who
40 places a blue cloak over the shoulders of her deceived husband

66

(compare the English expression 'to place horns on his head'), and the man who casts roses (instead of pearls) before swine. Close to this group, a hypocritical monk attaches a flaxen beard to the face of Christ; beyond, the impatient man 'sits on hot coals' beside a stream where we see the familiar big fish gobbling up their smaller victims. Hardly a corner, doorway or window is without one or more proverbs; they even spill out into the landscape at upper right. Here the opportunist warms himself before a burning house; the cautious man 'keeps an eye on the sail', and silhouetted against the distant horizon we can discern the pathetic figures of the blind leading the blind.

44

41

BRUEGEL'S MOST
ENCYCLOPAEDIC
PRESENTATION: THE
NETHERLANDISH
PROVERBS
(pl. 44, details pls. 35–42)

35 A pillar-biter, or
hypocrite (detail of 44)

36 Carrying both fire and water (dissimulating)

37 Butting one's head against a brick wall

38 Tying the devil to a cushion

39 Armed to the teeth and belling the cat

40 The 'blue cloak' of the deceived husband

41, 42 Netherlandish proverbs (details of 44). On the horizon the blind can be seen leading the blind

A parallel to this astonishing picture can be found in the fifth book of Rabelais's *Gargantua and Pantagruel*, in which a group of royal officials feverishly act out similar proverbs. The fifth book, however, was published only in 1564, some five years after the completion of the *Netherlandish Proverbs*. Bruegel's immediate prototype was probably an etching by the Malines artist Frans Hogenberg. Published by Bartholomeus de 43 Mompere no later than 1558, when several impressions of it were recorded in Plantin's possession, the print shows many proverb scenes scattered in a hilly terrain. Bruegel repeated almost all of Hogenberg's subjects, but added more to attain a total of over eighty-five. For the additional figures, he probably turned to some of the proverb books then in circulation. His picture, however, was not simply a collection of picturesque old saws painted for the delectation of linguists and antiquarians. That it had a more serious purpose is suggested by the inscription which appears at the top of Hogenberg's etching: 'This is generally called the Blue Cloak, but it would be better named the world's follies.'

43 Frans Hogenberg *The Blue Cloak*, c. 1558,
illustrating over 40 different Flemish proverbs

MEEST GHENAEMT
ISEN HĒ BETER BETAEMPT

44 *Netherlandish Proverbs* or *The Blue Cloak* 1559

The follies of the world had long preoccupied the moralists of northern Europe. They inspired Sebastian Brant's *Ship of Fools* and Erasmus's *Praise of Folly*, as well as *Het Leenhof der Ghilden*, best translated, perhaps, as the 'Court-Register of the Guilds', a long satirical poem by the Antwerp *rederijker* Jan van den Berghe, published in 1564. One aspect of human folly was often symbolized by the Blue Cloak, the proverb which both Hogenberg and Bruegel placed in the foregrounds of their compositions. Specifically the Blue Cloak alludes to the unfaithful wife, but as blue was the traditional colour of deceit, it also possessed wider connotations. In the procession held in Antwerp in 1563, mentioned in the previous chapter, one of the floats carried an old woman named 'Old Deceit who blinds Everyman with the Blue Cloak so that he seeks himself, but never finds what he is seeking.' Bruegel had already treated Everyman's spiritual plight in the *Elck* drawing of 1558, and it may be assumed that the *Netherlandish Proverbs*, like Hogenberg's etching, presents a similar moral commentary.

Bruegel, however, vastly improved upon his model. He replaced Hogenberg's abstract landscape with a realistic village setting, perhaps influenced by an anonymous Flemish 45 engraving which had appeared about 1550, depicting proverbs associated with Sloth. He also endowed his figures with an animation and comic power totally absent in Hogenberg's puppet-like creatures. The man strewing roses, for example, expresses an open-mouthed surprise at the indifference of the pigs to his largesse. To the left, the two old women with yarn and spindle ('one spins while the other winds', said of malicious gossips) are totally absorbed in their work. Above them, the man bearing light in a basket (said of those engaged in futile enterprises) strains at his burden, his eyes and cheeks bulging with exertion. In performing their crazy charades with a single-minded devotion that most of us reserve for more serious tasks, Bruegel's villagers well symbolize the absurdity and self-deception of most human endeavours, the lesson which Erasmus had already taught in his *Praise of Folly*.

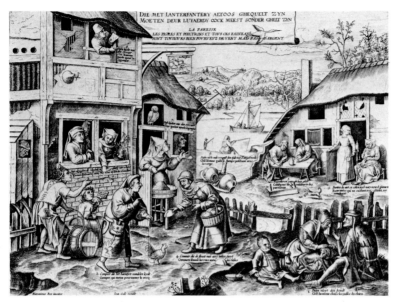

45 Anon. *Peasant Village with Proverbs on Sloth, c.* 1550

The extension of folly over the face of the earth is suggested in the *Netherlandish Proverbs* by the many diminutive figures filling the deep landscape at upper right: 'the number of fools is infinite' (Ecclesiastes 1:15). By this means, and far more effectively than in Hogenberg's etching, Bruegel gave vivid expression to one of the favourite Biblical passages of his day, and it is not fortuitous that the panoramic format of his picture, with its elevated viewpoint and high horizon, has something in common with the landscapes of Patinir and his followers. Renaissance man liked to contemplate not only nature but also his fellow creatures from a lofty position. Seen from this perspective, the world appeared like a vast stage or amphitheatre in which human life was an absurd spectacle. Inherited from classical antiquity, this concept of the *Theatrum Mundi* or Theatre of the World pervaded much of sixteenth-century thought and literature. When Abraham Ortelius

77

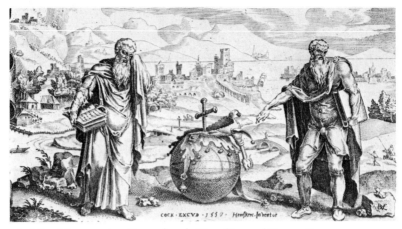

46 After Maerten van Heemskerck *Heraclitus and Democritus* 1557

published his great atlas of 1570, he entitled it *Theatrum Orbis Terrarum* (*Theatre of the Orb of the Earth*); maps, it seems, must have appealed to many viewers as expressions of the same philosophical attitude. Closer in spirit to Bruegel's picture, however, are the words spoken by Erasmus's Folly as she looks down on earth from the realm of the gods: 'There is no show like it,' she exclaims, 'Good God, what a theatre. How strange are the actions of fools.' Elsewhere Folly tells us that men exhibit so many kinds of folly each day that 'a thousand Democrituses would not be sufficient for laughing at them, and even then there would be work for one more Democritus, to laugh at those who are laughing.'

Democritus was the ancient philosopher who saw the world only as an object for laughter, in contrast to his companion Heraclitus, who wept at its miseries. They exemplified two attitudes well known in the Renaissance, as can be seen in an engraving after Heemskerck which Cock published in 1557. While some sixteenth-century moralists followed Heraclitus, most of them, like Erasmus and Jan van den Berghe, preferred to emulate Democritus. After all, as Luther's friend Melancthon observed, laughter was healthier than weeping, and Montaigne claimed that it was also more Christian, for to weep at the world

demonstrated too great an interest in it. The village in the *Netherlandish Proverbs* cannot fail to arouse our laughter, no matter how 'stiff, morose or surly' we may be, to borrow Van Mander's phrase. In this picture, at least, Bruegel revealed himself as a follower of Democritus.

The attitudes of the *Theatrum Mundi* are equally pervasive in two other paintings closely similar in size and format to the *Netherlandish Proverbs*, the *Carnival and Lent* of 1559 and the *Children's Games* of 1560. Even more than in the *Netherlandish Proverbs*, the upward-tilted ground plane and the high horizon in these two panels create a broad stage for a vast and colourful multitude of scenes. In the *Carnival and Lent* a town square surrounded by Late Gothic architecture provides the setting for the mock combat in the foreground. Straddling a barrel and precariously balancing a fat pie on his head, pot-bellied Carnival jousts with an emaciated, dour-faced Lent. Carnival is attended by costumed mummers and musicians, and his weapon is a spit filled with roasted meats. Lent defends herself with a broiling-iron containing two small fish; her beehive crown resembles the one worn by Hope in Bruegel's *Virtue* series, but in this case symbolizes the Church, and her other attributes include a bundle of switches for scourging penitents. At her feet lie pretzels and other traditional Lenten fare. Followed by a group of children, her wagon is appropriately drawn by a monk and a nun.

It is not clear whether similar confrontations between Carnival and Lent were actually staged during the carnival season. However, they occur frequently in the art and literature of the period, including several *rederijker* plays, and probably inspired the famous war between Shrovetide and the sausages which Rabelais introduced into the fourth book of his *Gargantua and Pantagruel*. Frans Hogenberg also depicted the battle between Carnival and Lent in an etching which Hieronymus Cock published in 1558, one year before Bruegel's painting. Bruegel must have known this print, but he used it only as a starting-point for his own composition.

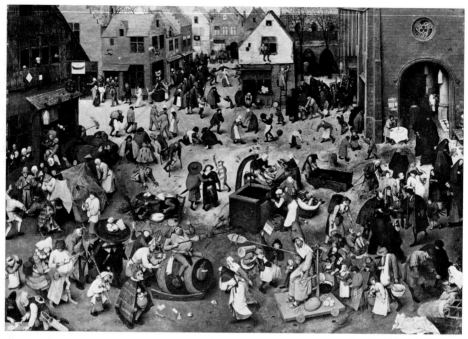

47 *Battle Between Carnival and Lent* 1559

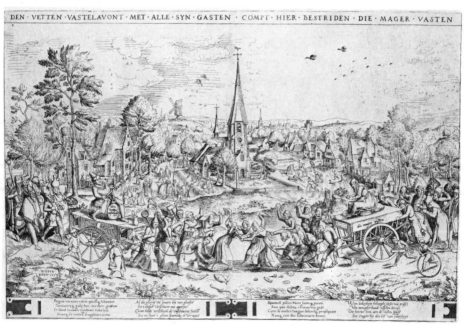

DEN · VETTEN · VASTELAVONT · MET · ALLE · SYN · GASTEN · COMPT · HIER · BESTRIDEN · DIE · MAGER · VASTEN

48 Frans Hogenberg *Battle Between Carnival and Lent* 1558

49
Carnival
and his
followers
(detail)

Hogenberg concentrated on the chief allegorical personages and their retinue. In Bruegel's painting, however, Carnival and Lent, not unlike the personifications in the *Virtues*, form the focal points for the numerous activities appropriate to each. An air of boisterous festivity prevails on Carnival's side of the square; the streets are filled with revellers, some in grotesque masks and costumes. Even beggars and cripples share in the communal merry-making; attired in their carnival finery, they dance and collect alms. A procession emerges from a street in the background. Two traditional folk-dramas are in progress; the *Dirty Bride* is performed at lower left before the tavern, while a crowd across the street watches a play involving a wildman, probably the old story of Valentine and Ourson.

In the centre of the square, the celebrations of Carnival give way to the austerities of Lent under the aegis of the Church. The mood here is one of devotion and good works. Within the church, the images have already been shrouded with white cloths in preparation for Lent. A crowd issues from the side door, returning home with the chairs and stools on which they have sat during a long sermon. Other people leave from the front entrance and give alms to the beggars and cripples who

50 Carnival merry-making (detail)

51 Lenten sobriety (detail)

have assembled expectantly. To judge from old copies of Bruegel's picture, a corpse and several more cripples were originally among the figures in this area; they were painted over by a later hand, perhaps at the behest of a squeamish owner. The fishmongers near the well are the Lenten counterparts of the pancake woman at the left.

The vivacious figure style recalls the exemplary scenes of the *Virtue* drawings; the church and other buildings are rendered with realistic detail. Yet the *Carnival and Lent* is not a record of a single temporal event witnessed by the artist. That the picture actually embraces a considerable span of time is indicated by the trees in the background. Those visible beyond the houses on Carnival's side are still bare, but the trees behind Lent have already acquired the thin green foliage of early spring. It is possible, as Gaignebet has suggested, that Bruegel was depicting the customs and other practices associated with the various feasts which occur from Epiphany to Easter Sunday. In its variegated spectacle of revelry, processions and almsgiving, the *Carnival and Lent* reflects the widespread enthusiasm of the sixteenth century for descriptions of social institutions and customs, such as we find in the immensely popular *Cosmography* of Sebastian Franck, first published in 1544. But Bruegel's picture was undoubtedly intended as more than a compendium of folklore and practices; like the *Netherlandish Proverbs*, it possesses a deeper significance. The moral license which inevitably prevailed at carnival time, despite repeated efforts to control it, was condemned by many preachers and satirists of the period. The same attitude is perhaps reflected in the signboard suspended from the tavern at the left in Bruegel's picture, bearing the image of a boat with the words 'In the Blue Boat'. The name 'Blue Boat' or 'Blue Barge' frequently designated the popular societies which helped to organize carnival revelries, but it also referred to drunkards, gamblers and others who squandered time and money in carousing. Their kind, in fact, was depicted in an engraving, the *Blue Boat*, which Cock published in 1559, purportedly after Bosch.

84

It might be assumed that in contrast to Carnival, the Lenten half of the picture presents the virtuous Christian life, as some scholars have suggested. However, we cannot be too certain. The inscription on Hogenberg's etching of this subject invites all men to the carnival feast because 'everybody likes to smear himself with fat', but it also recommends that those who prefer cheap food, like fish, can easily earn a reputation for sobriety during Lent. Erasmus and others complained about pious practices performed only for show, and it is not impossible that Bruegel's picture has a similar significance: false piety is no better than dissolute living.

The encyclopaedic character of the *Netherlandish Proverbs* and the *Carnival and Lent* is also apparent in the *Children's Games*, in 54 which we gaze down upon a city given over almost entirely to children. Ranging from toddlers to ungainly youths, they roll hoops, walk on stilts, spin tops, ride hobby-horses, engage in mock tournaments, play leap-frog, shout into empty barrels – over eighty games and pastimes have been identified. The lush green countryside at upper left affords some relief to this frantic activity, but even here we encounter several children swimming in a stream. The dark colours of the costumes, dominated by ochres, browns and other earth tones, contrast strikingly with the pinkish blue of the architecture and the shimmering foliage at left.

In the iconographical cycles of the Renaissance, children at play represented Youth in the Ages of Man, and Spring among the Four Seasons; they could also symbolize the human condition in general. In an anonymous Flemish poem published in 1530 in Antwerp by Jan van Doesborch, humanity is compared to children who jump, run, play and follow their own foolish inclinations. The round-eyed, unblinking gravity with which Bruegel's children pursue their games suggests that they, too, symbolize folly, and it is significant that they have invaded areas of the city usually reserved for the conduct of adult affairs, including the large building overlooking the square.

52, 53 Riding hobby-horse, and a procession with Whitsun bride (details of 54)

54 *Children's Games*
1560

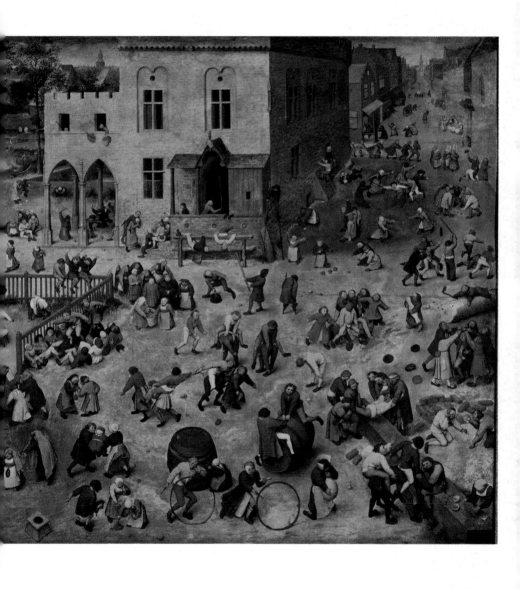

Perhaps a town hall or guild house, this building is filled with children who spin tops in the loggia, sit on the steps and dangle streamers from the upper windows. In the entrance, a boy amuses himself by balancing a broom on one finger. No picture could better convey the futility of mankind's professions and pretensions as they were viewed by Erasmus and other satirists.

These three paintings, the *Netherlandish Proverbs*, the *Carnival and Lent*, and the *Children's Games* did not exhaust Bruegel's interpretations of the *Theatrum Mundi*. He evoked it again in

55 King Saul (detail of 56)

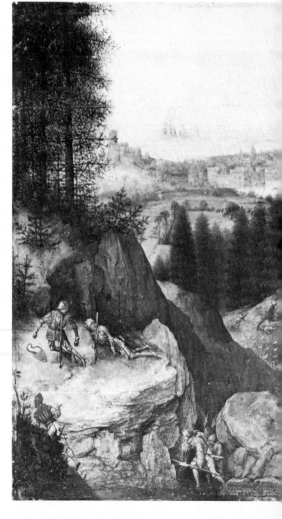

56 *The Suicide of Saul* 1562

the *Suicide of Saul* of 1562, in which the Philistines swarm 55
through a mountain pass like an army of ants. The chief episode
of this picture, the suicide of King Saul and his lieutenant 56
(I Samuel 31:4–5), occupies an inconspicuous place in the lower
left corner, the diminutive figures almost lost in the vast
mountainous landscape. Bruegel's most memorable in-
terpretation of the *Theatrum Mundi*, however, would appear in
the *Triumph of Death*, which also represents the culmination of
Bosch's influence on his art.

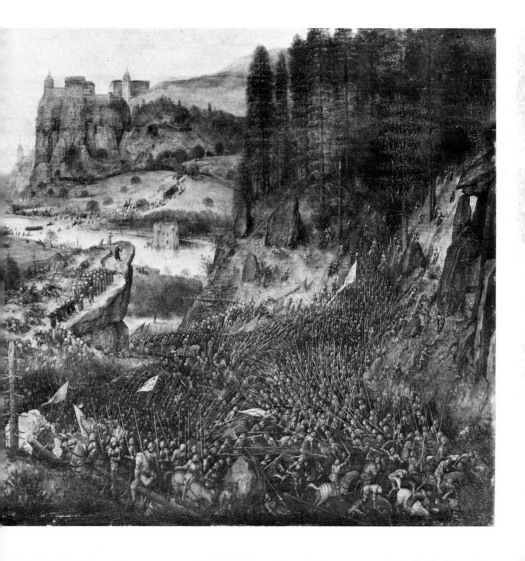

CHAPTER FIVE

New visions of Earth and Hell

Bruegel's last two or three years in Antwerp were marked by new developments in his landscape style. Equally significant was his continued experimentation with Bosch's imagery.

Although the designs for the *Large Landscape* prints may not have been completed until about 1560, as some authorities believe, Bruegel had already begun to rework his Alpine experience in the so-called *Small Landscape* drawings dated between 1559 and 1562. Many of these depict mountainous terrain and studies of rocks, occasionally surmounted by fortresses. About half the size of the *Large Landscapes*, they are generally more restricted in viewpoint, and less influenced by the conventions of Flemish landscape-painting. One of the finest drawings in this group is the *Mountainous Landscape with*
57 *Sunrise*, in which a valley and distant mountain range are boldly contrasted with huge jagged rocks thrust into the immediate foreground at the right. The upper peaks are wreathed by clouds not yet dispersed by the sun whose rays fill much of the sky. The delicate style of Bruegel's earlier landscape-drawings has given way to a more vigorous draughtsmanship. The forms are more summarily rendered, with a greater emphasis on the play of light and shadow.

In several other sheets in this group, Bruegel explored
59 scenery of an entirely different sort. A drawing of 1560, for example, shows several cottages with thatched roofs nestling among trees. Chickens scratch on the ground before one of the houses at the right and a peasant lounges at the gate, gossiping with travellers on the road. Just one year before this drawing, in

90

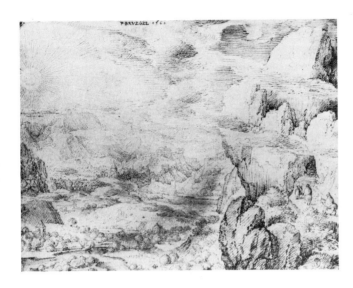

57 *Mountainous Landscape with Sunrise* 1561

58 *The Tower of Babel*, second version *c.* 1568 (for detail and first version see 65, 66)

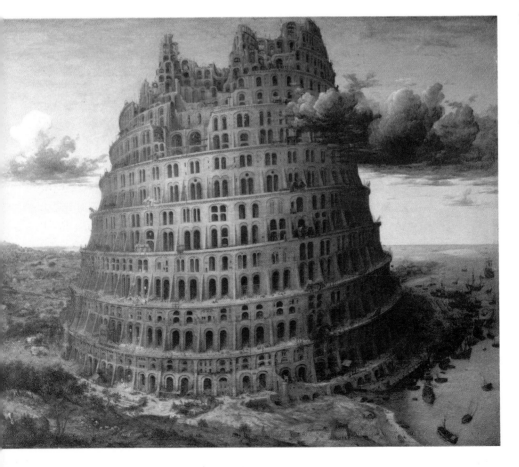

59 Landscape with a Village and a Family Walking in the Foreground 1560

1559, Hieronymus Cock issued a set of prints depicting views of the countryside around Antwerp. Their subjects and compositions may well have inspired Bruegel, but he avoided the careful, detailed draughtsmanship of the anonymous artist who designed them. He rendered the tiny figures on the road, as well as the sunlight flickering on the trees, with a style even sketchier than that of the small Alpine scenes.

These unpretentious views of rustic life would bear results in some of his later paintings, most notably the *Parable of the Blind* and the *Peasant and the Nest Robber*. His adherence to the traditional panoramic style, however, is evident in his one attempt at etching, the *Landscape with Rabbit Hunt* which Cock published in 1560 (the date on the print was previously misread as 1566). The softly diffused forms, created by rapid, spontaneous strokes of the etching-needle, has much in common with Bruegel's sketches of the Brabant countryside, but the composition recalls the *Large Landscapes*, especially the

60

60 *Landscape with Rabbit Hunt* 1560

St Jerome in the Wilderness. The panoramic style also appears in the *Suicide of Saul* (1562) and the *Flight to Egypt* (1563), as we have seen, as well as in the *View of Naples* (Rome, Galleria Doria), which recent scholars date to the same period. Likewise, in the enigmatic *Two Monkeys* of 1562 (Berlin-Dahlem, Staatliche Museen), the background displays a panorama of a harbour, perhaps Antwerp, painted in soft blues and pinks against an overcast sky.

This same conception of landscape is equally evident in Bruegel's imposing *Tower of Babel* of 1563. The picture is 65 dominated by an edifice that arises from the flat plain like some great mountain, towering over the large rocks and cliffs which it has assimilated during the course of construction. The topmost stories are obscured by clouds, not unlike the mist-hung peaks in the *Mountainous Landscape with Sunrise*, and its mammoth bulk casts a shadow on coast and sea. At lower left, a group of stone-workers kneels before the giant Nimrod.

93

61 *Fall of the Rebel Angels* 1562 (for detail see 68)

62 *Dulle Griet, c.* 1562–4 (for details see 69, 72–3)

BRUEGEL'S MOST
IMPORTANT
EXCURSIONS
INTO BOSCH'S
WORLD IN
THREE ORIGINAL
PAINTINGS
(pls. 61, 62, 74)

63 Death on a
red horse,
detail of *The
Triumph of
Death* (see also
74–8)

In Genesis 11:1–9 we learn that Noah's descendants assembled to build a tower reaching to Heaven. For this blasphemous enterprise they were punished by God who caused them to speak in mutually unintelligible tongues and scattered them throughout the earth. This brief account was expanded in the *Jewish Antiquities* of Josephus Flavius (second century AD) who named Nimrod as the instigator and supervisor of the construction. Josephus's version influenced the Flemish artists of the earlier sixteenth century, who frequently represented this subject. One of their compositions, known to us from a miniature in the Grimani Breviary and from a panel by an 64 anonymous follower of Patinir, was probably Bruegel's immediate source. Improving on his model, however, Bruegel dramatically increased the difference in scale between the tower and the vast plain stretching towards the distant hills. New also 66 was his depiction of the interior construction of the tower, whose forms recall the Colosseum at Rome. Perhaps this was a reminiscence of his trip to Italy, but he could also have studied the Colosseum and similar buildings in the views of Roman ruins published by Hieronymus Cock in 1550 and 1561.

58 Bruegel returned to this subject in a second, smaller picture, probably painted some years later; in the fluidly painted foliage, it resembles the *Magpie on the Gallows* of 1568. This version achieves an even more awesome monumentality through the lower horizon and the omission of Nimrod. The Cyclopean structure seems to crush the earth beneath it and dwarfs even the great bank of clouds clustered along one side. The upper levels dissolve into a forest of scaffolding and uncompleted vaults, the fresh red brick gleaming in the sunlight. In contrast, the older brick below has weathered to a more yellow hue, suggesting that the tower, like so many Gothic cathedrals, has consumed centuries in its construction. The workmen who labour on the ramps or climb the scaffolding appear hardly larger than specks of dust.

In both versions of the *Tower of Babel* Bruegel displays a remarkable knowledge of engineering and building, but the

96

significance of these pictures is uncertain. The Tower of Babel was a traditional image of human pride and presumption in the face of God; as such it appears on one of the floats in a procession held in Antwerp on the Feast of the Circumcision in 1561. But it was also generally assumed that all modern languages, and several ancient ones, had descended from the builders of the Tower. This last belief must have been particularly attractive in Antwerp, where dictionaries and other books were published in many tongues, and where in 1566 Plantin began preparing the *Polyglot Bible*, a monumental work in six languages, including Hebrew and Chaldean. And in a time of religious strife, Bruegel's pictures of the Tower of Babel probably reminded viewers of a bygone age when all men shared a common faith and purpose.

64 School of Joachim Patinir *The Tower of Babel*

97

65 *The Tower of Babel* 1563

66 Detail of 58, revealing Bruegel's remarkable knowledge of building and engineering

During the early 1560s, Bruegel continued to produce drawings for Cock's engravers. Among these were the *Thin Kitchen* and the *Fat Kitchen*, both of 1563, the *Feast of Fools* and other moralizing subjects. He also drew a *Christ in Limbo*, replete with a multitude of Bosch-like monsters, but his most important excursions into Bosch's world during these years appear in three highly original paintings, the *Fall of the Rebel Angels*, the *Dulle Griet* and the *Triumph of Death*. 61, 68
62, 74

Of this group, the earliest was probably the *Fall of the Rebel Angels*, dated 1562. The revolt of Lucifer and his angels is not recounted in the Old Testament, but was a Jewish legend which had passed into Christian theology. Bruegel represented the Fallen Angels already transformed into monsters as they tumble headlong out of the bright circle of Heaven, a writhing mass of loathsome forms. St Michael and his companions slash away in their midst, while trumpeting angels above seem to be answered by the raucous demons below, a pandemonium of sound to reinforce the pandemonium of shapes. Helmeted creatures, toads, bladders, ominous floral growths all mingle in indiscriminate profusion.

The creatures in the *Fall of the Rebel Angels* represent Bruegel's most brilliant improvisations of Bosch-like form – but even here he could not equal Bosch's conceptions, as we see, for example, if we compare the butterfly-winged monster in the lower centre with its likely prototype, a thistle-headed knight astride a jug in the centre panel of Bosch's *St Anthony* triptych. Neither the dragons biting their own bodies nor the winged heads staring in pop-eyed terror at their doom detract from the festive atmosphere of this demonic carnival. One of Bruegel's best-preserved works, the *Fall of the Rebel Angels* is dominated by bright hues which flash out from the sombre background: lemon-yellows, cherry-reds and apple-greens. These cheerful tonalities are complemented by the azure sky above and St Michael's golden armour, while in the silvery sheen of the fish monsters, Bruegel anticipated the virtuosity of the Dutch seventeenth-century painters of still-life.

In an altarpiece of the same subject done some seven years earlier, Frans Floris had depicted both the good and bad angels as Herculean figures whose bulging muscles recall the nudes of Michelangelo and Tintoretto. How different are Bruegel's angels; their slender bodies, adolescent faces and fluffy blond hair revive a type popularized in the previous century by Roger van der Weyden and his followers. Particularly close is a *Fall of the Rebel Angels* by Gerard David, painted early in the sixteenth century.

67

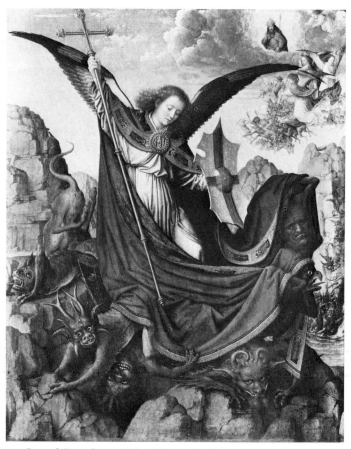

67 Gerard David *St Michael Triptych (Fall of the Rebel Angels)*

68 Angels above the mêlée (detail of 61)

62 The date inscribed on the *Dulle Griet* is partly illegible and has been read as 1562 and 1564, but it is generally agreed that the picture was painted fairly close in time to the *Fall of the Rebel Angels*. The setting this time is Hell; on a bridge at lower right, devils are attacked and plundered by a band of housewives. This militant group is led by an old hag who strides determinedly across the centre foreground, her sparse grey hair flying out

69 wildly from beneath her cap. She grasps a sword and carries an odd assortment of gold and silver vessels and common household objects. Around her scamper the inhabitants of Hell; some seek to raise the drawbridge leading to a lugubrious Hellmouth where their companions have taken refuge. At lower right, other demons armed with lances emerge from beneath the bridge to repel the invaders.

The chief heroine of this bizarre picture has been variously described as a witch, as the personification of Greed or Anger, and as a goddess from the Icelandic Eddas. The clue to her proper identity, however, had already been given by Karel van Mander who described her as 'Dulle Griet, who loots at the mouth of Hell'. Van Mander's statement was carefully investigated by the eminent Belgian folklorist Jan Grauls, who discovered that 'Griet', diminutive for Margaret, was a traditional name in Netherlandish literature and folklore for any shrewish, quarrelsome woman. Grauls further observed that 'Dulle' should be translated not as 'mad' or 'crazy', as is generally done, but as 'wrathful', 'angry', or 'hot-tempered'. Finally Van Mander's account of her curious activity refers to a proverb current in Bruegel's day: 'He could plunder in front of Hell and return unscathed.'

Grauls' interpretation is substantiated by a play presented at the Antwerp *Landjuweel* of 1561, in which a group of wayward women includes 'Griet who plunders in front of Hell'. In a proverb book published in Kampen in 1551, moreover, the relevant expression is rendered as '*she* could plunder in front of Hell and return unscathed'; significantly, it appears among a group of proverbs describing the plight of henpecked husbands.

102

It seems likely, therefore, that Dulle Griet thus personifies the quarrelsome woman who seeks mastery over her husband. A stock character in medieval and Renaissance comic literature, the shrewish wife often demonstrated her dominance by appropriating her husband's trousers. In an anonymous Flemish engraving of about 1560, 'Jan de Man' and his fellows engage in a futile effort to keep their breeches; the objective of their wives is clearly indicated by the banner carried by one of them, inscribed *Overhand*, or 'Upper Hand'. Bruegel's heroine does not wear trousers, but the pieces of armour she wears were considered equally unsuitable. These include a breastplate, a mailed glove and a sort of metal cap on her head, and this martial costume is parodied by the little helmet-monster on the wall behind her. From her left side dangles a knife, another traditional male attribute, as is the sword brandished in her right hand.

The proverb 'to plunder in front of Hell' undoubtedly inspired the infernal setting in which Bruegel placed his virago, but it was also widely acknowledged that not even Satan himself could withstand the shrewish wife on the rampage. The Devil's fear of old women is the subject of several humorous plays and poems by the sixteenth-century German dramatist Hans Sachs, and a similar motif appears in several prints of the period. Contemporary opinion on this subject is echoed in Goedthals' proverb collection of 1568: 'One woman makes a great din, two women a lot of trouble . . . five an army, and against six, the Devil has no weapons.' Bruegel introduced an even greater number of women to plunder and torment the unfortunate devils. One fearless housewife even ties her victim to a cushion, probably illustrating another proverb, as Grauls has suggested, describing the shrewish wife. The proverb is unknown to us in its sixteenth-century form, but Bruegel had already included it in his *Netherlandish Proverbs* of 1559.

Despite their comic elements, the old tales and jokes concerning nagging wives and shrews who could frighten the Devil undoubtedly reflect the great dislike, even fear, with

Aut amat, aut odit Mulier, nil tertium habere
Dicitur: insanum in furor Imperium.
Unde superba suum itaque iussura maritum
Et velata, teneri vellet ipsa. MENDOS. HR.

Bisher een

Waer de Vrouw d'overhandt heeft en draecht de brouck
Daer ist dat san de man leest naer aduys van den douck

On la feme gouuerne, portant la banniere
Et des brayes auerq le tout y va derriere

70 Anon. 'Overhand':
the Battle for the
Breeches, c. 1560

71 Barthel Behem Old
Woman Attacking the
Devil

72, 73 Woman shown as wasteful, and as a match for the Devil (details of 62)

which aggressive and domineering women were generally regarded. From the Middle Ages on, it was accepted as divinely ordained that woman should submit to man just as the flesh should submit to reason. Basically unstable, if she threw off the male yoke woman was apt to run wild, indulging in her inordinate lusts and ill temper. One of her besetting sins was extravagance, perhaps alluded to in the grotesque creature who sits on the roof of a shed just to the right of Dulle Griet and ladles
72 out coins from its egg-shaped posterior to the woman below. Grauls has suggested that this figure was inspired by the expression 'to ladle with a big spoon', signifying waste and prodigality. Although such views concerning women did not go unchallenged, they persisted far into the sixteenth century.

In his satirical poem published in 1564, for example, Jan van den
Berghe included a long section condemning bad wives; among
their many faults, he noted that they disobey and contradict
their husbands, and think that they are wiser than men.

Viewed within the context of these traditional attitudes,
Dulle Griet and her ravaging army may be understood as
archetypes of all women who usurp masculine perogatives or
otherwise defy standards of behaviour considered proper for
them. We shall never know, of course, if Bruegel's picture
expresses his personal sentiments or those of some patron who
commissioned it, and we can only guess at the particular
circumstances which prompted this unusual reworking of old
motifs into a composition of such complexity. Perhaps it was

inspired by the unusual independence which Flemish women seem to have enjoyed during Bruegel's lifetime. Guicciardini tells us they were freer in the Netherlands than elsewhere to conduct their own business affairs, but he also complained that such independence, joined with 'the natural avidity of women to dominate', made them proud and imperious and often quarrelsome.

It may also be significant that when the *Dulle Griet* was painted, the Netherlands, France, England and Scotland were all governed by women. This was not unusual in the Netherlands, where Margaret of Parma continued a tradition of female regents begun in the early sixteenth century, but England came under feminine rule for the first time in centuries with the accession of Mary Tudor and then Elizabeth I to the throne; Catherine de' Medici had been Regent of France since the death of Henry II in 1559, and in 1561, Mary Stuart became Queen of Scotland. This unusual conjunction of women rulers occasioned numerous treatises arguing against their right and ability to govern, the most notorious of these being John Knox's *The First Blast of the Trumpet against the Monstrous Regiment of Women*, of 1558. 'No woman raised aloft in authority will be able to resist the feeling of pride,' Knox thundered, 'and he who judgeth it a monster in nature, that a woman shall exercise weapons, must judge it a monster of monsters that a woman shall be exalted above a whole realm and nation.'

Knox's fulminations were motivated by political and religious considerations, but his opinions were shared by more dispassionate observers, including the distinguished French jurist Jean Bodin. Although history has vindicated most of these women rulers, especially Elizabeth I, it would have been natural for Bruegel and his contemporaries to ascribe the ills of their time to the malice and ineptitude of female rule, and it is not impossible that their fears were given concrete expression in the figures of Dulle Griet and her horde pursuing their reckless way past the portals of Hell.

The *Triumph of Death* is undated, but was probably done in 74
the same period as the *Fall of the Rebel Angels* and the *Dulle
Griet*. Like the *Netherlandish Proverbs* and related paintings, the
Triumph of Death presents the panoramic format and elevated
viewpoint of the *Theatrum Mundi*; this time, however, Bruegel
depicted not the follies of mankind but the end of the world
itself in a new and terrifying form. Traditionally, the final
episode of human history was represented as the Last Judgment,
where in the company of saints, Christ determines the eternal
destiny of each human soul, and Heaven and Hell wait to
receive their own. Even Bosch's powerful *Last Judgment*
triptych in Vienna had not departed significantly from this
concept; Bruegel himself had depicted a fairly orthodox version
of this subject in a drawing of 1559, based on a Bosch-like
engraving by Alart du Hameel, and apparently intended to
conclude the series of the *Seven Deadly Vices*.

No divine judge, however, presides in the *Triumph of Death*,
and the forces of Hell have been reduced to a few monsters and a
burning tower in the centre of a desolate landscape. No demons,
but the dead themselves besiege the living in their final hour.
Led by a giant figure of Death on a red horse, an army of rotting 63
corpses and skeletons herds its victims into a huge van-like box
at the right; it is flanked by other skeletons drawn up in orderly
ranks behind their coffin-lid shields. At the lower right, an 75
enemy detachment falls upon a group of merry-makers. A fool
in a chequered coat tries to crawl beneath the banquet table, and 76
several men have drawn their swords in a pathetic effort to
defend themselves. At the left, other victims are led away or
crushed beneath the death cart. This carnage is supervised by a
group of dead men on a bridge, clad in winding-sheets draped
like togas over their emaciated bodies. On the other side of the
river in the middleground, a group of the living mounts a last-
ditch attempt to stem the armies of death advancing upon them
from two directions, and other scenes of execution and torture 77
fill the landscape beyond. The sky glows with a huge confla-
gration, and ships sink beneath the oily grey-green waters. 78

THE TRIUMPH OF DEATH
(pl. 74, details pls. 63, 75–8, 80,
82–3)

74 *The Triumph of Death, c.* 1562–4

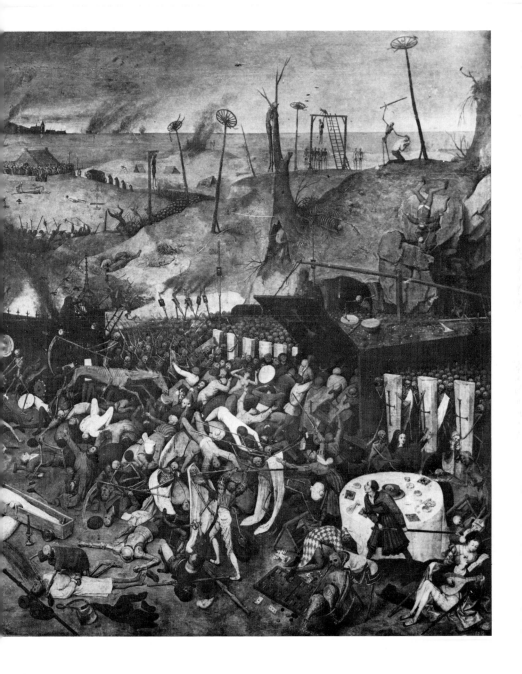

75 Skeleton army drawn up behind their shields (detail of 74)

76 The jester crawls for refuge beneath a table (detail of 74)

77 Imagery of torture and
solitary death (detail of 74)

78 A ship sinks beneath the
oily waters (detail of 74)

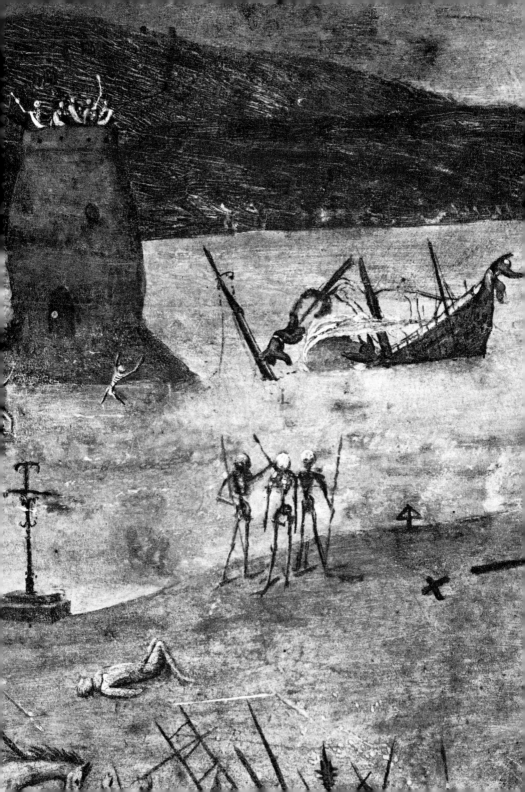

The earth yielding up its dead had long been accepted as one of the signs which would herald the end of the world, and this event probably formed the basis of Bruegel's composition. His apocalyptic landscape, however, synthesizes many other images with which men of the later Middle Ages expressed their fear of death and the afterlife. One of these was the meeting of the three living and the three dead, in which the latter were often shown attacking their living counterparts, as occurs, for example, on 94 the bottom of a page in the Grimani Breviary. Another image was the Dance of Death, in which the dead lead away various living representatives of human society. Its influence can be discerned at lower left, where the dead carry away a pilgrim, a king and a cardinal. It is also reflected in the musical instruments played by several of the dead. The skeleton riding the bone cart 83 grinds out a tune on a hurdy-gurdy, while the skeleton on top of the death van at the right beats out a macabre rhythm on a pair of kettledrums. This last figure was probably inspired by a woodcut in the famous *Dance of Death* series after Hans Holbein the Younger, republished several times during Bruegel's lifetime. And the banqueters interrupted by death is a subject frequently treated by artists of the fifteenth and sixteenth centuries.

In none of these earlier images of death, however, do the dead fall upon the living in such overwhelming numbers, nor do they comport themselves in such an orderly, military fashion. Indeed, Bruegel's *Triumph of Death* seems to parody the battle scenes which were so popular with his contemporaries, such as the Victories of Charles V, celebrated in tapestries after the cartoons of Cornelis Vermeyen, and in engravings after 79 Johannes Stradanus. Bruegel thus presents death not so much as the punishment for specific human sins and follies, but as the destiny of all men, regardless of piety, social rank or wealth. In 80 using military imagery as the organizing principle for his picture, Bruegel surely intended a biting indictment of war, for no matter who wins, death is the ultimate victor. It was a lesson, alas, that the sixteenth century too often forgot.

116

79 After Johannes Stradanus *A Victory of Charles V*

80 Bruegel's army of death (detail of 74)

The *Triumph of Death* marks the climax of Bruegel's preoccupation with Bosch's visionary art. Although Bosch's direct influence appears only in occasional details, this picture, of all of Bruegel's works, comes closest to the older master in its apocalyptic power. Yet it is precisely in the *Triumph of Death* that the essential difference between the two artists becomes most clearly apparent. This can be seen, for example, if we compare the lovers on top of the cart in Bosch's *Haywain* 81 triptych with the similar group in the lower right corner of 82 Bruegel's picture. Lovers banqueting and making music had long symbolized the sin of Lust, and Bosch's lovers still function largely as abstract symbols, much like the devil near by who serenades them through his snout. Bruegel's lovers, in contrast, are depicted with greater physical and psychological realism, and the slight frown on the face of the gallant gazing at his mistress suggests that he is gradually becoming aware of the grim musician who has joined their song. Similarly vivid details can be found elsewhere in the picture. In this synthesis of medieval allegory with the data of immediate human experience, Bruegel not only surpassed Bosch, but created a potent image of universal death and destruction which would be equalled only several centuries later by Goya's *Disasters of War* and, still later, by Picasso's *Guernica*.

81 Lovers in Bosch's *Haywain* triptych

82 Lovers (detail of 74)

83 Death plays the hurdy-gurdy (detail of 74)

A change of city, a change of style

In the spring of 1563, Pieter Bruegel was married to Mayken Cocks in the Church of Notre Dame de la Chapelle in Brussels. As we may remember, Mayken was the daughter of Bruegel's former teacher, Pieter Coecke van Aelst, and she and her mother, Marie Verhulst, were apparently living in Brussels at the time of the wedding. Probably in the same year, Bruegel also moved to Brussels; according to Van Mander, this was at the insistence of Marie Verhulst who hoped that he would thereby forget a former mistress with whom he had lived in Antwerp. Many scholars regard the demands of a mother-in-law as an insufficient motive for Bruegel's change of residence, and some have assumed that he left Antwerp to avoid persecution for unorthodox religious beliefs. It has been suggested, in fact, that Bruegel was a member of the so-called 'Family of Love', an heretical sect which included Abraham Ortelius, Christopher Plantin and prominent members of the Antwerp merchant class.

The Family of Love, or Familists, was founded by the German merchant Hendrick Niclaes, mystic and self-styled prophet, who preached that the true Christian could achieve a personal communion with Christ without external aids, and that all dogmas and ceremonies were unnecessary to salvation. Unlike the Anabaptists and other Protestant groups with which Niclaes's ideas show some affinity, the Familists displayed few radical tendencies in their behaviour, and generally practised their beliefs with great discretion. Indeed, Niclaes advised his followers to conform to the outward forms of the official religion, for the Familists regarded all established faiths with

equal indifference. Thus both Ortelius and Plantin lived as apparently loyal Catholics and successfully defended themselves against charges of heresy. Plantin seems to have published clandestine editions of Familist literature, but he also issued breviaries and other Catholic books; he received support for his *Polyglot Bible* from Philip II, who named Plantin 'Archtypographer to the King' in 1570, making him in effect the censor of all books published in Antwerp.

Given Bruegel's close relationship with Ortelius and with Cock, who had many business connections with Plantin, it is very possible that he was familiar with Familist beliefs. He may well have belonged to their group, but we have no documentary evidence for this assumption. It would also be difficult to discern the influence of exclusively Familist ideas in his art. This is true even of the *Death of the Virgin*, a picture 93 which Ortelius owned and greatly admired. While there is no precedent for the figure of the sleeping St John the Evangelist visible at lower left, the dying Virgin receives Extreme Unction according to traditional Roman Catholic practice. It was, in fact, a curious picture to be cherished by someone who rejected all religious rituals.

In any case, as Grossmann has correctly observed, had Bruegel fled Antwerp to escape religious persecution, he would hardly have sought refuge in Brussels, where any heretical activity would have been more closely scrutinized by the Inquisition. In contrast to commercial, cosmopolitan Antwerp, governed by a generally tolerant middle class, Brussels was aristocratic, the residence of the Regent Margaret of Parma and her Court, and of Granvella, created Archbishop of Malines in 1559 and elevated to the rank of Cardinal two years later. The city was dominated by the ancient palace of the old dukes of Brabant, adjacent to a great hunting-park. Close by were the palaces and gardens of William of Orange and other Netherlandish nobles, then in the early stages of their struggle with the Spanish Crown. Brussels was also a major centre of tapestry-weaving in the Netherlands. In 1517, Pope Leo X had

sent to Brussels the famous cartoons of the *Acts of the Apostles*, designed by Raphael and his assistants; all but one of these cartoons were still there when Bruegel arrived, and had provided models for other tapestries, including a set for Philip II.

Bruegel's arrival in Brussels occurred soon after the completion of the Willebroek Canal in 1560–1, linking Brussels with Antwerp by means of the Scheldt River. It was an enormous project which Guicciardini later praised as 'being worthy of an emperor or prince'. As we have seen, Bruegel was engaged by the magistrates of Brussels to produce a series of paintings commemorating this canal, and while Van Mander tells us that this occurred just before the artist's death, it may well have been the prospects of such a commission, as well as the importunities of Marie Verhulst, which brought Bruegel to Brussels. There is no doubt, however, that he enjoyed the patronage of Cardinal Granvella. Bruegel could have met the Cardinal through Cock, who dedicated several engravings to him, or through the Antwerp banker Niclaes Jonghelinck, whose brother, the sculptor Jacob Jonghelinck, was one of the Cardinal's favourite artists. In addition to the *Flight to Egypt* of 1563, Granvella owned other paintings by Bruegel, some of which he was forced to abandon when he left the Netherlands in May 1564. How many of these he later recovered is unknown, but several pictures by Bruegel are listed in an inventory of his property in Besançon made in 1607. Among them was a *Parable of the Blind*, apparently not identical with the painting of this subject now in Naples.

Nevertheless, Bruegel did not sever his associations with Antwerp. For Cock's engravers he produced a pair of drawings, *St James and the Magician Hermogenes* and the *Fall of Hermogenes*, done about 1564, in which he turned once more to Bosch for inspiration. In 1565, Cock published a magnificent set of engravings after Bruegel representing sailing-ships. During this period, too, Bruegel also painted a number of pictures for the Antwerp banker Niclaes Jonghelinck. According to an inventory of 1566, they included a *Tower of Babel* (probably the

one in Vienna), a *Christ Carrying the Cross* and a series of the *Labours of the Months*.

The paintings which can be assigned to Bruegel during the years 1564–6 present an almost bewildering diversity of stylistic tendencies. As noted in the previous chapter, Bosch's influence persisted in the *Dulle Griet* and the *Triumph of Death*, both of which may in fact have been completed after his move to Brussels. Bruegel was also influenced by other Late Gothic artists, but far more significant for his artistic development was the art of Raphael and the Italian Renaissance.

One of the dated paintings of 1564 is the *Christ Carrying the* 87 *Cross*, probably the same picture of this subject owned by Jonghelinck, and Bruegel's largest surviving picture. On a wide plain curving away into the distance, multitudes of people swarm towards the hill of Golgotha on the right, where the gathering clouds presage the darkness which covered the earth at the time of the Crucifixion. Almost indiscernible in their midst, Christ collapses beneath the weight of the cross. A group 84 of tormentors, including an open-mouthed fool, kick and pummel him while a soldier on horseback looks on unconcernedly. But the crowd pays less attention to the plight of the Redeemer than to the two frightened thieves in a cart at 86 the right. The priests attending the thieves represent an anachronism that Bosch had already introduced into several of his Golgotha scenes. Another crowd has gathered at the left to watch Simon of Cyrene whom soldiers have seized to help bear Christ's cross. They are hindered in their task, however, by Simon's wife, who struggles fiercely to free him, her 85 uncharitable action belying the rosary dangling conspicuously at her waist. Everywhere children dart about in play while their elders gape in curiosity, diverted by the spectacle before them but totally uncomprehending of its significance. Bright greens, ochres and blues, accented by the red jackets of the soldiers, lend a festive air to the picture: a central event in Christianity has been transformed into a public holiday, another version of the *Theatrum Mundi*.

84 Christ falls

85 Simon of Cyrene and his wife

86 The two thieves

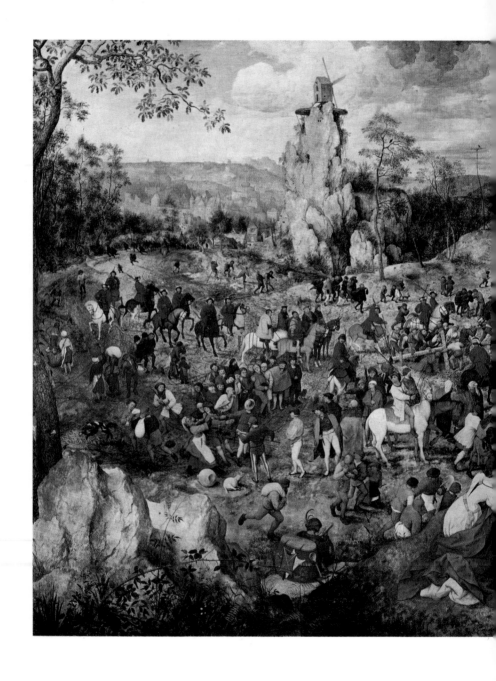

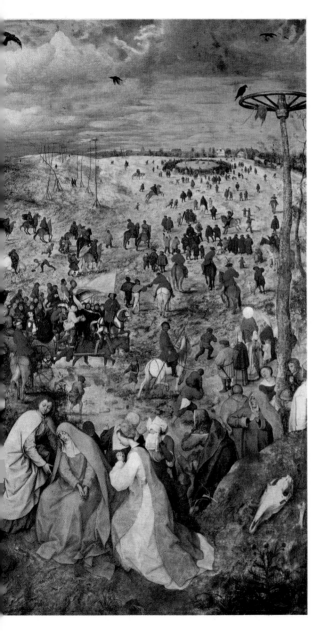

87 *Christ Carrying the Cross*
1564

88 Attr. Brunswick Monogrammist *Christ Carrying the Cross*

The *Christ Carrying the Cross* was Bruegel's monumental reworking of a subject which had preoccupied Herri met de Bles and other Flemish painters since the early sixteenth century. A version painted by Joachim Beuckelaer in 1562 anticipates Bruegel in the placement of the Holy Figures in the lower right corner, but Bruegel's immediate model was probably a picture by the so-called 'Brunswick Monogrammist'. Particularly comparable is the organization of the middle- and background terrain, the long line of people moving towards Golgotha, and the great rock jutting up in the centre of the landscape. In Bruegel's picture, this rock supports an oddly inaccessible windmill, inspired, perhaps, by the similar structure that dominates the right side of the Monogrammist's composition. Because they were used for grinding wheat, mills were traditional symbols for the Eucharist, and the windmills in these two pictures probably possess an analogous significance.

88

128

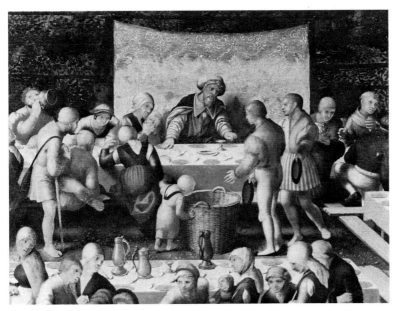

89 Brunswick Monogrammist *Feeding of the Five Thousand* (detail)

The sturdy, well-knit figures in Bruegel's *Christ Carrying the Cross* represent an advance over those in his *Netherlandish Proverbs* and *Carnival and Lent*; their limbs are more carefully modelled, their movements more convincingly portrayed. In this, too, Bruegel seems to have been affected by the Brunswick Monogrammist, who displays a comparable figure style in his *Christ Carrying the Cross* and, even more so, in his *Feeding of the Five Thousand*. Nothing is known of this anonymous artist, but 89 he is sometimes identified with the landscapist Jan van Amstel, brother-in-law and occasional collaborator of Pieter Coecke. Jan died in 1543. If this identification is correct, Bruegel could have encountered the art of the Brunswick Monogrammist as early as the 1540s when he was presumably working in Coecke's studio. Curiously enough, however, the Monogrammist's influence on Bruegel cannot be discerned until the *Christ Carrying the Cross* of 1564.

129

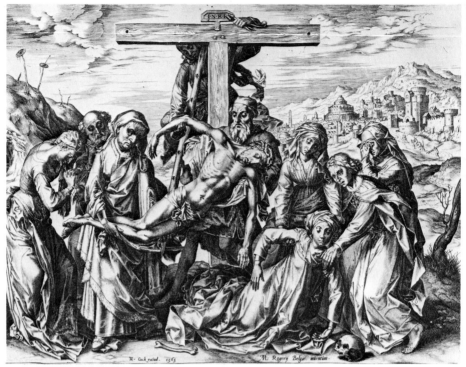

90 Cornelis Cort's engraving after Roger van der Weyden's *Descent from the Cross*

92 *Adoration of the Magi* 1564 ▶

91 Group of Holy Women (detail of 87)

Although his relationship with the Brunswick Monogrammist thus remains unclear, there is no doubt that Bruegel far surpassed the Monogrammist and his other predecessors in the expressive character of his figures and in his fidelity to contemporary dress and architecture. Earlier artists had often introduced Oriental costumes and other exotic details to indicate an event remote in time and place, but Bruegel depicted Christ's progress to Golgotha very much as a public execution of his own day. There are few exceptions to this 'local realism'. One is the bulbous-domed structure to be seen at the left in the distance, whose shape identifies it as the Temple of Jerusalem.

The other major exception occurs in the group of St John and
91 the Holy Women on the hill at lower right. With their slender, elongated proportions and the heavy, angular folds of their drapery, these figures seem to have stepped out of some Flemish altarpiece of the fifteenth century. They come particularly close to their counterparts in Roger van der Weyden's famous *Descent from the Cross*. This work had been in Spain since 1556, but Bruegel could have known its composition from the copy by Michiel Coxie, or from a preliminary drawing for Cornelis
90 Cort's engraving after this work, published by Hieronymus Cock in 1565.

This old-fashioned style was perhaps intended to suggest the timeless nature of the Virgin and her companions in contrast to the contemporary setting of the events beyond, but it also testifies to Bruegel's interest in earlier artists other than Bosch. We have already seen that he turned to Van der Weyden and David for the angels in the *Fall of the Rebel Angels* of 1562. Echoes of Dirk Bouts and Memling also appear in his *Resurrection*, a monochrome drawing probably done about the same time (Rotterdam, Museum Boymans-van Beuningen) Hardly less old-fashioned is the exquisitely painted grisaille of
93 about 1564, the *Death of the Virgin*. Its composition and artificial lighting harks back to traditional deathbed scenes illustrating the Office of the Dead in earlier Flemish books of hours; a close

parallel, in fact, occurs in the Grimani Breviary, painted by Simon Bening and his workshop in 1505–10. 94

It is frequently assumed that these retrospective tendencies reflect Bruegel's decisive rejection of the prevailing Italianism in favour of the native style. In view of his study of Raphael, to be examined later, this conclusion appears unwarranted, but Bruegel's archaisms do coincide with a new and growing interest among his contemporaries in the art of the older Netherlandish masters, of which Cort's engraving after Roger van der Weyden was but one symptom. This interest seems to have been stimulated by Giorgio Vasari's *Lives of the Artists*, which proudly chronicled the accomplishments of Italian artists from Cimabue to Michelangelo. First published in 1550, it was being read and emulated in the Netherlands by the end of the same decade. In 1559, the Ghent poet-painter Lucas de Heere composed an ode praising the Ghent Altarpiece of the Van Eyck brothers; about the same time, the Liège poet Dominicus Lampsonius corresponded with Vasari, supplying him with information about Flemish artists for the second edition of the *Lives* (1568). Lampsonius also composed a rhymed history of Flemish painting, now lost, and contributed laudatory poems to the series of engraved portraits of ancient and contemporary Flemish painters, including Bruegel, which was published by Cock's widow in 1572.

It is very likely, therefore, that Bruegel's patrons appreciated his evocations of great artists of the past. Archaizing tendencies also appear in Bruegel's other dated painting of 1564, the *Adoration of the Magi*, his earliest known picture with large-scale 92 figures. Framed by a simple wooden shed, the two older kings approach from the left, ceremoniously presenting their gifts to the Christ Child ensconced in his mother's lap. The youngest king awaits his turn at the right. Behind the Magi stand their retainers, among them an archer and a band of lance-bearers. As in the *Christ Carrying the Cross*, the bystanders seem quite unaware of the significance of the event. They gossip among themselves and admire the rich gifts; one of them whispers into

the ear of a white-bearded Joseph. Bruegel's gift for rendering expressive human faces is displayed in the hooded eyes and dourly drooping mouth of the king standing at the left, the somewhat bemused expression of the bearded man above him, and the bespectacled man on the other side who gazes, it seems, with open-mouthed greed at the richly decorated vessel held by the Moorish king. The reds, pinks and purples are contrasted with the greyish tans and dull greens, making this one of Bruegel's most colouristically splendid paintings.

The elaborate costumes of the two older kings echo the Epiphany scenes of earlier Flemish painters, including those produced by Pieter Coecke and his workshop. The magnificent pinkish robe with deeply slashed borders worn by the Moorish king may have been inspired by Bosch's early *Epiphany* (now in the Johnson Collection, Philadelphia), or one of its many copies. Among these retrospective elements, however, the graceful pose of the Child strikes an incongruous note, and it is possible, as some authorities suppose, that Bruegel's model was Michelangelo's marble *Madonna and Child* which had stood in the Church of Notre Dame in Bruges since 1506. Likewise, the dense arrangement of many large figures within a restricted space suggests the influence of Italian compositional methods.

The impact of Italian art is even more apparent in a small painting which Bruegel did the following year, the *Christ and the Woman Taken in Adultery* of 1565. It is the second of the three pictures executed in grisaille, the other two being the previously mentioned *Death of the Virgin* and the *Three Musician Soldiers* recently acquired by the Frick Collection, New York. All relatively small in scale, they are delicately painted in various shades of grey on a yellow background occasionally touched with brown. Although the *Death of the Virgin* and the *Christ and the Woman Taken in Adultery* were later reproduced in engravings, it is unlikely that they were originally made for this purpose. Indeed, Bruegel seems to have painted the *Christ and the Woman Taken in Adultery* for himself, as it remained in his possession and was inherited by his son Jan.

93 *Death of the Virgin, c.* 1564

94 Deathbed scene from the Grimani Breviary, and below, *The Three Dead Attack the Three Living, c.* 1505–10

95 Christ and the Woman Taken in Adultery 1565

This last picture depicts an episode recounted in John 8: 3–11, in which the Pharisees brought an adulteress before Christ. Knowing that the law of Moses prescribed death by stoning for this crime, they maliciously asked him for his judgment. Christ did not reply immediately, but stooped to write something on the ground. When the Pharisees persisted in their questions, he answered: 'He who is without sin, let him cast the first stone.' Bruegel showed Christ inscribing these words in Netherlandish on the pavement; behind him the Apostles watch intently, as do the Pharisees on the right, one in eager expectation of confounding him. But several Pharisees have already begun to turn away, in accordance with the Biblical account which tells us that finally only the woman remained, and her Christ bade to

136

96 Raphael *Christ's Charge to St Peter*, c. 1516

'go and sin no more'. She also watches Christ, standing isolated between the Apostles and the Pharisees.

The graceful contrapposto of the woman's figure is distinctly Italianate in style, and Stridbeck has suggested that Bruegel's composition was influenced by several paintings of the same subject from the circle of Pieter Coecke and other Italianate Flemish painters. None of these versions, however, possess the austere monumentality of Bruegel's picture. The close-knit organization of the figure groups flanking Christ and the alignment of their heads on approximately the same level have much more in common with Raphael's cartoons, especially the *Healing of the Lame Man* and *Christ's Charge to St Peter*. And 96 while Bruegel's figures lack the supple rhythmical movement

97 *Four Men Standing in Conversation*, c. 1565

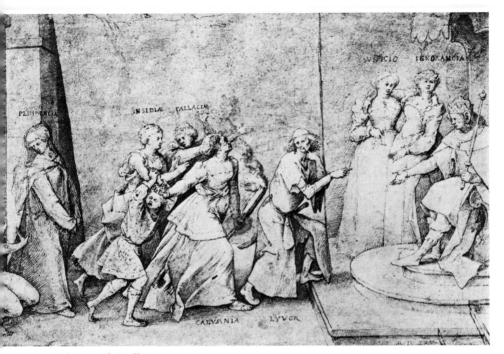

98 *Calumny of Apelles* 1565

of Raphael's forms, the simple massive folds of their draperies achieve something of his classic gravity.

A comparable style can be discerned in one of the few *naer het leven* drawings (drawings 'after life') which can be un-questionably attributed to Bruegel, the *Four Men Standing in Conversation*. The cubic planes of the robe worn by the figure with his back to the viewer recalls an Apostle on the left in the grisaille painting, while the head of the bearded old man at the right repeats the type employed for one of the Pharisees. The drawing, executed with quick, vigorous strokes of the pen, must have been done about the same time as the picture.

Bruegel's interest in Raphael's art probably began while he was still in Antwerp. In a very damaged *Adoration of the Magi*, painted in tempera on linen (Brussels, Musées des Beaux-Arts) probably in the middle 1550s, he combined tall, slender figures

97

99 *Massacre of the Innocents, c.* 1566

reminiscent of Bouts with a composition adapted from a
Raphaelesque cartoon of the same subject, perhaps encountered
in the engraved copy issued by Cock. The *Christ and the Woman
Taken in Adultery*, however, remains Bruegel's most ambitious
attempt to assimilate the formal vocabulary of Italian
98 Renaissance art. Even the *Calumny of Apelles*, a drawing done
the same year in pen and ink (London, British Museum) and
one of the few classical subjects he ever depicted, is far less
Italianate in style. Nevertheless, his study of Raphael prepared
him for the large scale compositions of his last years, and it may
also help explain the new coherence of design which
distinguishes several of his multi-figure Biblical scenes, such as
101, 99 the *Census at Bethlehem* of 1566, and the *Massacre of the Innocents*,
generally dated about the same time.

140

100 Detail of the *Census at Bethlehem* (see 101)

101 *(overleaf) Census at Bethlehem* 1566

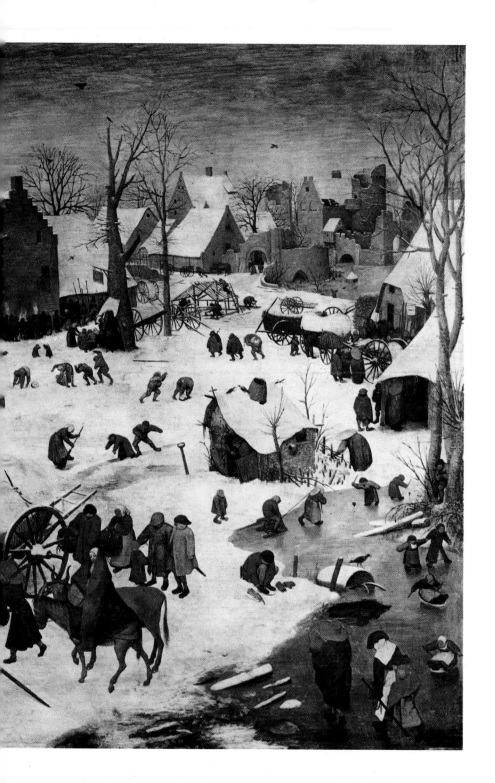

The *Massacre of the Innocents* exists in several versions. The
99 one in Vienna is usually considered a good workshop
production partly retouched by Bruegel, but it gives us a better
idea of the original composition than does the version in
Hampton Court Palace; the latter picture, while of higher
quality, was sadly disfigured by a later artist who sought to
mitigate the cruelty of the subject by transforming the children
into barnyard animals.

As in the *Christ Carrying the Cross*, Bruegel translated both
Biblical stories into the forms of contemporary life. In the
101 *Census at Bethlehem*, based on Luke 2:1–5, he depicted a Flemish
village on a cold December evening; the red ball of the setting
sun has begun to slip behind the trees at the left. Peasants trudge
through the ice and snow from all directions, converging on the
inn at lower left, where a crowd has already gathered to pay its
taxes. Amid the bustle, no one notices the presence of Joseph
leading the Virgin on a mule. In the *Massacre of the Innocents*
another peasant village has been invaded by an army of soldiers
who carry out Herod's command with cold-blooded
efficiency. The villagers protest and plead in vain as their
children are slaughtered before their eyes. This grim business is
supervised by a detachment of armoured knights in the centre,
led by a sinister grey-bearded man dressed in black, perhaps
Herod himself, whom earlier artists often showed directing the
massacre in person.

The village settings of both pictures recall such earlier works
by Bruegel as the *Carnival and Lent* and the *Children's Games*.
However, the viewpoint is more unified, and the rather casual
scattering of figures and groups in the earlier pictures, also
apparent to some extent in the *Christ Carrying the Cross*, has
been replaced by more carefully articulated compositions. In
the *Massacre of the Innocents*, the branches and barrels on the
frozen pond in the foreground create a diagonal movement
leading towards the group of peasants and horsemen at the left.
The many figures in the middleground are integrated into
distinct groups, dominated by the commander and his troops.

144

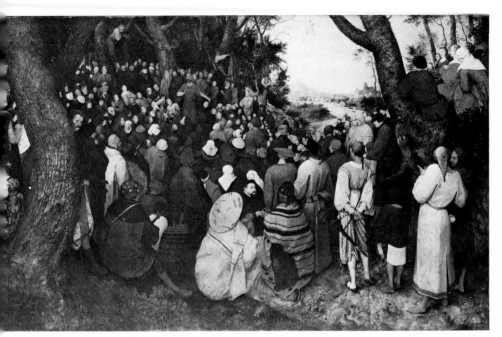

102 *Sermon of St John the Baptist* 1566

In the *Census at Bethlehem*, the carts and barrels in the middle foreground establish two diagonals, one echoing the line of figures crossing the water at upper left, the other repeating the row of houses at the right.

This more unified pictorial structure also appears in another picture of 1566, the *Sermon of St John the Baptist*. The Saint stands in the middleground amid a sea of upturned faces that flows from the bystanders at the lower right to the grove of trees in the left distance. This powerful diagonal movement into space is framed at the left by a massive, twisted tree-trunk, as imposing as the spiral columns in Raphael's *Healing of the Lame Man*. The colourful costumes and many figures have been subordinated to a simple, almost architectonic composition. That this new monumentality had already affected his landscape style is evident in the great *Labours of the Months* series, which Bruegel painted in 1565.

102

CHAPTER SEVEN

Calendar and kermis

For centuries, the annual progression of the seasons had been represented by the agricultural labours, and occasionally the recreations, appropriate to each month. In the later Middle Ages the labours of the months commonly illustrated the calendar of feast-days in books of hours, of which the most famous is the *Très Riches Heures* painted by the Limbourg Brothers in 1411–16. Early in the following century, this manuscript seems to have been in the Netherlands where it inspired a series of calendar illustrations by Simon Bening and his circle, including the Grimani Breviary. By Bruegel's day, the labours of the months had become very popular subjects for domestic decoration, ranging from modest wooden plates to elaborate allegorical tapestries.

146

103 *February* from a
Flemish Book of Hours
c. 1535

104 *July* from the same
Book of Hours

Of Bruegel's *Months* cycle, only five panels have come down
to us. Three are in Vienna: *Hunters in the Snow*, *Gloomy Day* and
Return of the Herd. A fourth picture, *Haymaking*, is in the
National Museum in Prague, while the Metropolitan Museum
in New York possesses the *Wheat Harvest*. All but the
Haymaking are dated 1565, and they were most probably the
series of 'Twelve Months by Bruegel' mentioned a year later in
the inventory of Niclaes Jonghelinck's collection.

107–8
111, 109

110

The inventory, however, does not indicate the specific
number of panels in the series, and as no other pictures from the
Months have apparently survived, even in copies, De Tolnay
and others have argued that the original series consisted of only
six panels, each depicting two months. Such an arrangement is
not without precedent, but Bruegel probably painted the more
usual number of twelve pictures. The most important evidence
for this assumption is the separate depiction of haymaking and

147

wheat-harvesting, activities which traditionally illustrated two adjacent summer months, usually July and August. It is likely, therefore, that Bruegel's other paintings also represent individual months. If the precise identification of some of the panels proves difficult, this is chiefly because the iconography of the older calendar series was seldom consistent.

In composing his landscapes, Bruegel turned directly to the earlier Flemish calendar scenes in the tradition of Simon Bening. Particularly close to his *Months* is a Flemish calendar painted in Bening's workshop about 1535. These or other illuminations like them might have been known to Bruegel through Marie Verhulst, whom Guicciardini described as a famous miniaturist in her own right. Nevertheless, such calendar scenes provided only a starting-point for Bruegel's artistic imagination.

Bruegel seems to have been fascinated with winter scenes during the mid-1560s. In addition to the *Census at Bethlehem* and the *Massacre of the Innocents*, he also painted a *Winter Landscape with Bird-trap* in 1565 and, two years later, the *Adoration of the Magi in the Snow* (Oskar Reinhart Collection), but in none of these paintings did he convey the chill rawness of winter as vividly as in the *Hunters in the Snow*.

The *Hunters in the Snow* represents a bitter day in the depth of winter. Three peasants trudge down the hill at left, followed by a pack of hounds whose slender bodies and tails create graceful patterns against the snow. Below lie several ponds dotted with skaters and a village huddled round the parish church. The all-pervading bleakness of the landscape is reinforced by the choice of colours: a dull green sky reflected in the darker greens of the frozen ponds and river, the greyish-black cliffs rising in the distance. The figures and cottage walls contribute the only warm accents to these frigid tonalities.

As in several of his earlier Alpine engravings, Bruegel combined homely details of the Flemish countryside with a mountainous panorama. The painting, however, surpasses the prints in the firm structure and grandeur of its composition. The

103–4

105
106

107

148

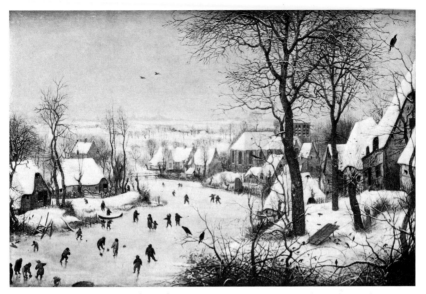

105 *Winter Landscape with Bird-trap* 1565

106 *Adoration of the Magi in the Snow* 1567

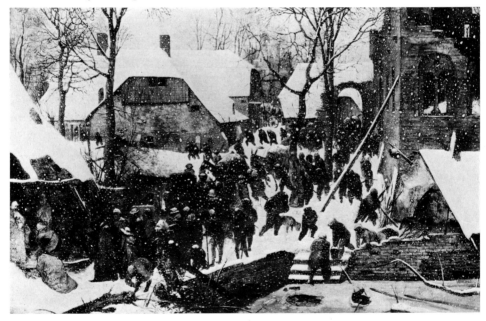

bare trees provide firm vertical accents at the left before dissolving into a lacy network of branches above; they also reinforce the descending line of the hill to create a strong movement into the right distance. Similarly, the transition from one level of the landscape to another is accomplished with a new subtlety. This picture thus bears the same relationship to the earlier landscapes as the *Census at Bethlehem* does to the *Carnival and Lent*. The *Hunters in the Snow* also reveals Bruegel's freedom in handling the traditional motifs. Peasants hunting

THE FIVE PANELS OF THE
MONTHS CYCLE
(pls. 107–11, details pls. 126–8)

107 *Hunters in the Snow* 1565
(for detail see 126)

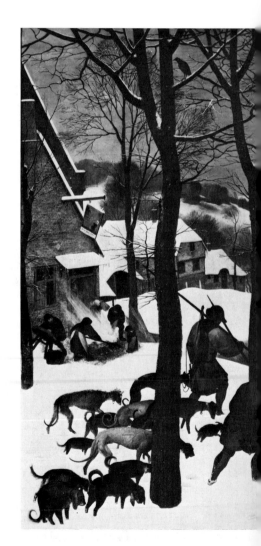

had characterized both December and January in the old Flemish calendars; the singeing of the slaughtered hog before the tavern at left could symbolize either November or December. But as Grossmann has pointed out, the strong diagonal movement of the composition towards the right suggests that this picture was intended to occupy the first place in the series, and hence it probably represents January.

In the *Gloomy Day* the icy calm of the preceding picture has given way to winter storm. Angry clouds scud across the sky at

108

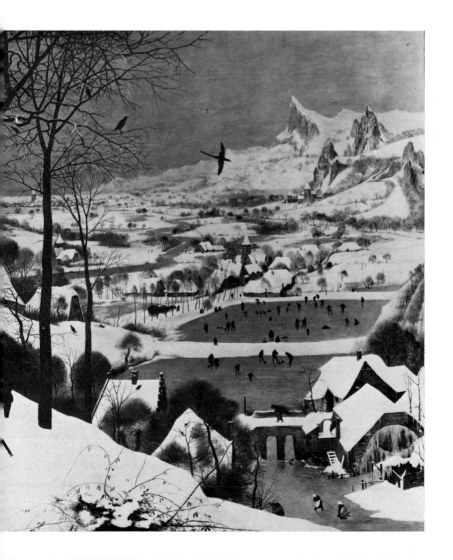

127 upper left and gales churn the waters, tossing the tiny ships. The picture is bisected by a group of trees, their trunks and branches forming an intricate pattern against the sky. Muddy blues, sombre grey-greens and browns dominate the landscape from which only a few areas gleam: the distant mountain-peaks at the left and, on the opposite side of the picture, the front of a cottage and the costumes of the peasants who have climbed from the valley below. The waffles eaten by one of the peasants at lower

108 *Gloomy Day* 1565 (for detail see 127)

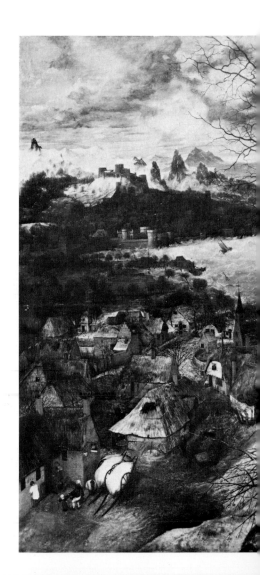

right, and the paper crown worn by the child near by mark them as carnival revellers, and their presence makes it likely that this picture represents February, usually the time of Carnival. It was also one of the months for pruning trees and binding twigs, tasks performed by several of the peasants at left. In the February page from the Flemish calendar of about 1535, previously referred to, peasants are similarly occupied while a storm rages on the lake behind them.

Like its counterpart in the earlier calendar scenes, the
109 *Haymaking* or *July* depicts an opulent summer landscape, the
sky warm and clear except for a few wisps of cloud. The terrain
is gently undulating, its forms softly rounded; even the cliffs at
left appear less rugged than Bruegel usually showed them.
Organized in parallel planes, the landscape moves through a
succession of slopes and fields to one of Bruegel's most
enchanting vistas, its delicate blue tonalities recalling Patinir.
The haymakers are combined with the fruit and vegetable
harvesters, a rare motif generally associated with August in the
152 old calendars. In the foreground three women return from the
fields; the movement of their bodies possesses a Raphaelesque
grace, and the two younger women have a physical
attractiveness seldom encountered in Bruegel's art.

110 In the *Wheat Harvest* or *August*, the field hands have paused
beneath the tree at lower right for their midday meal. One man
stretches out in sleep, his mouth opened in a snore. The tranquil
countryside beyond is traversed by a broad, semicircular
128 movement encompassing the edge of the wheatfields, the
meadows and roads and terminating in the left background.
The overcast and humid weather is perfectly rendered by the
greyish pink of the sky and distant lake and by the subdued
grey-green of the foliage and meadows in the middle distance.

111 The *Return of the Herd* shows farmers driving their cattle into
winter quarters from summer pastures on the upper slopes.
Leafless trees and withered fields bear witness to the advanced
stage of autumn, while the dark, ragged clouds at the right
herald the coming snow and sleet, an ominous sign despite the
rainbow beneath. The year is drawing to a close, although it is
not entirely clear which month is represented. The return of the
cattle to their barns is probably Bruegel's original invention;
some years later, Lucas van Valckenborch introduced this motif
into a landscape illustrating November (Vienna, Kunsthistor-
isches Museum). That Bruegel's picture might be October,
however, is suggested by the grape harvest depicted on one of
the lower slopes, a detail commonly associated with this month.

154

109 *Haymaking* or *July, c.* 1565 (for details see 152–3)

110 *Wheat Harvest* or *August* 1565 (for detail see 128)

Reminiscent of such earlier landscapes as the *Parable of the Sower* of 1557 and the *Flight into Egypt* of 1563, the *Return of the Herd* none the less shares the monumentality of the other *Months*. Parallel diagonal movements into space are established by the procession of cattle and the river flowing below. This composition is framed by trees on both sides and dominated by two basic colour areas, the grey-blue of the sky and the browns of the cattle and the autumnal landscape.

The *Labours of the Months* lack the fine detail and careful execution found in many of Bruegel's other paintings. The brushwork is rapid, the paint applied in thin layers and the forms loosely rendered; the underdrawing is visible in places. These pictures were undoubtedly painted to be viewed from a distance, and the complete cycle in its original setting, presumably a large room in Jonghelinck's villa, would have constituted a superb decorative ensemble. None of the surviving panels are alike in colour or composition. Even the two summer months are distinguished by different atmospheric conditions.

In the *Months*, Bruegel subordinated the world of man to the world of nature. Even more than in his earlier landscapes, they are truly cosmic in scope, depicting seasonal fluctuations of weather as they occur over great stretches of the earth's surface. In thus placing the yearly round of humble rustic duties within this vast framework of earth and sky, Bruegel went far beyond the simple calendar scenes which had been his models. Their grandeur comes closest, perhaps, to the landscapes described in Virgil's *Georgics*. In this majestic poem on rural life, Virgil moves constantly, and with consummate ease, from the most mundane details of farming and cattle-breeding to rhapsodic descriptions of the celestial constellations and the great meteorological forces affecting the world.

It is tempting, therefore, to suppose that Bruegel's radical transformation of the old calendar scenes was inspired by Virgil himself, for the *Georgics* was widely read and admired in the sixteenth century. He could have been introduced to this poem

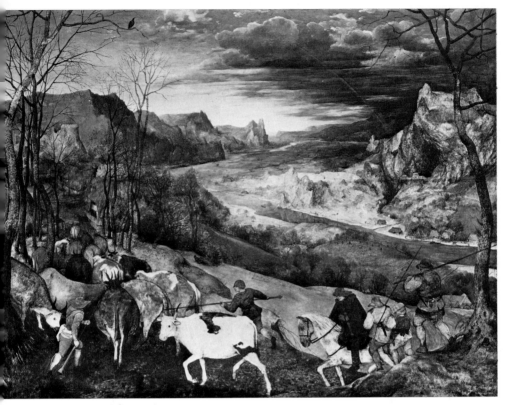

111 *Return of the Herd* 1565

by Jonghelinck, whose own humanistic tastes are well documented. Some ten years earlier, Jonghelinck had commissioned Frans Floris to decorate a room in his villa with scenes depicting the Labours of Hercules. Similar interests, in fact, might have motivated him to commission Bruegel's *Months* as further decoration for his home, for he would have known from Pliny the Elder and Vitruvius that the ancient Romans often had scenes of peasants and rustic landscapes painted on the walls of their villas and palaces.

However this may be, the *Labours of the Months* depict peasants very much as a wealthy landowner would have viewed

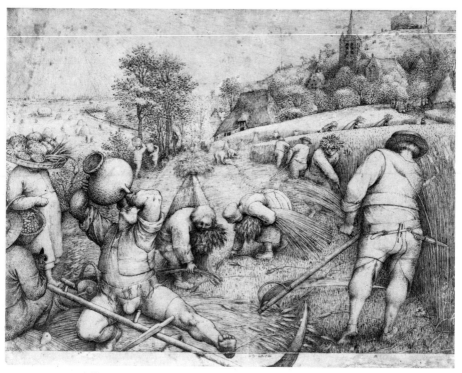

112 *Summer* 1568

them, as the anonymous tenders of his fields and flocks. Bruegel often enhanced this anonymity by showing the peasants with their backs to the viewer or their faces hidden beneath wide-brimmed hats. Similar devices can be found in his *Spring* and *Summer*, two drawings dated 1565 and 1568 respectively and published by Cock in the latter year as part of an engraved *Four Seasons* set. In *Summer*, the head of the robustly proportioned mower is obscured by the great water-jug tilted to his mouth, while the head of the woman near by almost disappears beneath a tray of vegetables balanced on her head. This latter motif also appears several times in the *Haymaking*, where baskets seem to sprout from the necks and shoulders of the peasants descending the road at lower right.

The peasants thus exemplify the agricultural routine and wealth of the land very much as they did in a procession held in Antwerp in 1561. On this occasion, a group of milkmaids, egg-wives and other countryfolk followed a great horn of plenty on a wagon entitled the 'Vale of Fruitfulness'. But there was another pictorial tradition which focused not on the labours of the peasants, but on their pleasures and recreations. Already in the fifteenth century, shepherd dances had been depicted on French and Flemish tapestries, and in the next century, Hans Sebald Beham and other German artists produced numerous prints of peasant weddings and kermises or church festivals. These subjects also appeared in the Netherlands after mid-century in the paintings of Pieter Aertsen and the engravings of Pieter Baltens and Pieter van der Borcht. Bruegel's earliest 113 peasant scene of this nature was probably the *Kermis at Hoboken*, 114 of which the original drawing, dated 1559, is in the Courtauld Institute, London. In a leisurely, anecdotal fashion recalling the *Carnival and Lent*, he depicted a church procession and the games and other activities associated with a village festival. Engraved by Frans Hogenberg and published by Bartholomeus de Mompere, it is one of the few designs which Bruegel made for someone other than Cock.

The shop of the Four Winds, however, soon responded to the growing popularity of peasant subjects. Beginning about 1561, Bruegel produced for Cock's engravers the *St George Kermis*, compositionally related to the *Kermis at Hoboken*, as well as a rustic wedding dance which displays certain affinities with his earliest known painting of the same subject, the *Peasant Wedding* 115 *Dance* of 1566, now in Detroit.

The surface of the Detroit picture has apparently suffered considerable abrasion, but the powerful forms of the basic composition remain intact. In the centre, couples stomp to the music of two stout bagpipers puffing away at lower right. The distended codpieces of the male dancers testify to the uninhibited gaiety of the occasion. The bride has left her seat of honour among the trees in the right background to join the

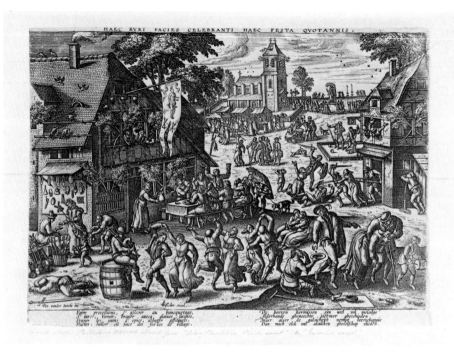

113 Pieter van der Borcht *Peasant Kermis*

PEASANT FESTIVALS
(pls. 113–17, details pls. 122–4)

114 After Bruegel *Kermis at Hoboken, c.* 1559

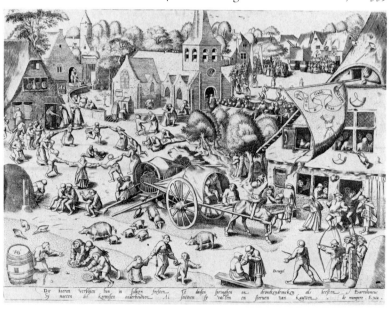

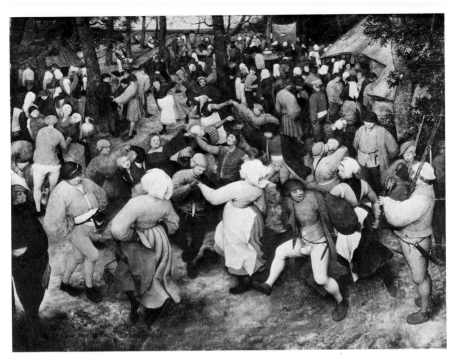

115 *Peasant Wedding Dance* 1566

festivities. Dancing at the back of the group towards the left, she is clad in a black dress, her hair falling freely to her shoulders in conformity with a bridal custom of the day. The movement of the dance is reinforced by the kaleidoscope of forms and colours, dominated by the white caps and aprons of the matrons and the bright reds of some of the other costumes. Against these shifting patterns, the tree-trunks provide stable vertical accents.

Sometime later, Bruegel painted the *Peasant Kermis* and the *Peasant Wedding Feast*, both in Vienna. Although neither picture bears a date, their figure style shows close parallels to Bruegel's dated works of 1567 and 1568, to be examined in the next chapter, and they were probably done about the same time. Similar in size and figure scale, these two panels may have been planned as a pair.

116
117

The crowded composition and elevated viewpoint of the Detroit *Wedding Dance* still recall the style of Bruegel's earlier multi-figure compositions. In the two Vienna pictures, however, he completely abandoned this panoramic format; the point of view is lower, the figures are reduced in number and increased in scale. The *Peasant Kermis* introduces us to a village festival; a man and woman rush into the scene from the right to join the dancers in the middleground. The male dancer in the centre forms a visual transition between the foreground couple and the old bagpiper and his companion seated at the left, the latter balancing an enormous beer-pot on his knee. Two children near by ape their dancing elders, and behind, a quarrel erupts among a group of peasants seated at a table, while a lumpish couple embrace.

The *Wedding Feast* takes place in a barn, probably just after harvest, for the rear of the building is filled with hay to the rafters, and the traditional last sheaves of wheat hang prominently at upper right. The guests sit on crude stools and benches round a long table, entertained by two bagpipers, one of whom has paused in his playing to gaze longingly at the food. On the far side of the table the bride sits in state. The paper crown hung above her head reflects a contemporary practice, and her modestly lowered glance and folded hands were apparently *de rigueur* for such occasions, for brides assume similar poses in many other Flemish wedding scenes of this period. The cloth of honour behind her, however, is distinctly a makeshift affair, suspended between a wooden post and a pitchfork thrust into the hay. Equally improvised is the unhinged door which the two stalwart youths in the right foreground have appropriated as a serving-tray, and from which their companion distributes bowls among the guests. Perhaps, as Grauls has suggested, the bowls contain *rijstpap*, a popular sweet porridge of rice boiled with milk and spices and sometimes coloured with saffron.

Near the serving-men, a priest and a bearded man quietly converse together, apparently oblivious of the chatter of the

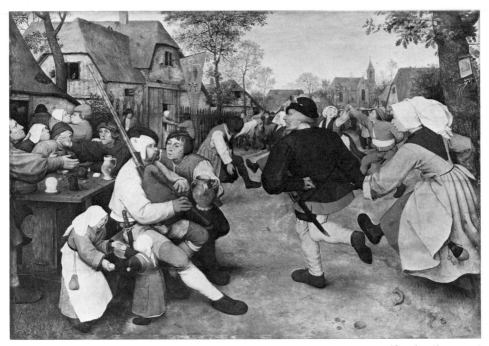

116 *Peasant Kermis c.* 1567–8 (for detail see 123)

117 *Peasant Wedding Feast, c.* 1567–8 (for details see 124–5)

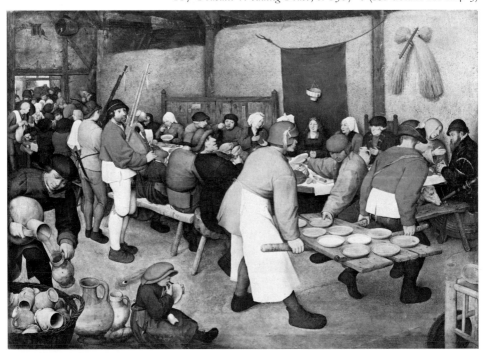

other guests. To judge from his costume, the bearded man is of a higher social class than the peasants, and some scholars have identified him as a self-portrait of the artist, on the basis of his resemblance to Bruegel's engraved portrait of 1572. At the other end of the table, additional guests crowd into the entrance of the barn. Unlike the bride, the groom cannot be readily distinguished, and writers have exercised considerable ingenuity in explaining his supposed absence. The groom, however, appears to have been accorded less distinction than the bride in sixteenth-century Brabant. Indeed, he may even be one of the serving-men, comforming to a contemporary custom by which the groom was obliged to wait upon the bride's family during the wedding banquet.

The three serving-men and their improvised tray establish a diagonal movement continued into the left background by the table. This vigorous thrust into space is countered at lower left by the man pouring beer and the greedy child licking its fingers. It is often assumed that the composition of the *Wedding Feast* was inspired by certain banquet scenes of Tintoretto, but Bruegel could have found models much closer to home, particularly in Flemish representations of the Marriage Feast at Cana. The diagonal arrangement of the table, for example, recalls a drawing of this subject, dated 1545, from the circle of Pieter Coecke. The beer-pourer busy among his pots also corresponds in pose and position in Bruegel's picture to the wine attendant in many Flemish Cana scenes of the time. But if Bruegel thus adapted the traditional Cana imagery for his rustic feast, it may have been for more than compositional purposes; perhaps he intended a humorous reminder to the viewer that it would take the miracle performed at Cana to satisfy the needs of his thirsty guests.

Already in the Detroit *Wedding Dance*, the peasants exhibit a sturdy corporeality and vigorous movement only hinted at in the *Christ Carrying the Cross* painted two years before. The Vienna panels, however, show this new mastery of the human form at its fullest development. The solidly constructed figures

164

118 Circle of Pieter Coecke van Aelst *Wedding Feast at Cana* 1545

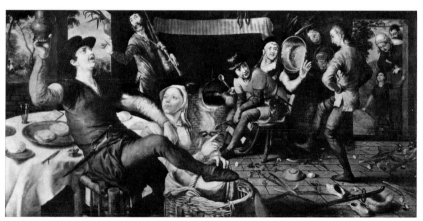

119 Pieter Aertsen *Egg Dance* 1557

are rendered in complex poses and with accurately foreshortened limbs, as can be observed, for example, in the bagpiper and his companion in the *Kermis*. Clothes are no longer conceived of as flat silhouettes. Thighs and leg muscles bulge through the trousers and leggings worn by the men; jackets swell with the rounded shapes of backs and shoulders. The two youths bearing the door in the *Wedding Feast* are massive bulks, almost sculptural in character. In these large and self-motivated figures, Bruegel was furthest from the inarticulate creatures which populate his earliest paintings. As a result of his study of Italian art, he was able to endow his peasants with the same physical impressiveness that other artists employed for Biblical and mythological heroes.

Bruegel was not the only Flemish painter to depict the peasant in such heroic terms. Both Pieter Aertsen and Joachim Beuckelaer produced many large pictures representing people of the lower classes, including household servants and market peasants, sometimes with Biblical scenes in the background. A good example of their art can be seen in Aertsen's *Egg Dance* of 1557. The old bagpiper who looks greedily at the beer-pot raised by the young man in the foreground anticipates the similar motif in Bruegel's *Wedding Feast*, but otherwise the two works have little in common. With their slender torsos and elegant poses, Aertsen's figures seem a race apart from Bruegel's coarse, earthy peasants, and while Aertsen included several admirably rendered heads, they cannot approach those in Bruegel's pictures for vitality and animation.

Bruegel often depicted humanity as an anonymous mass, each man scarcely distinguishable from his neighbour. The same rounded faces with staring fish-like eyes and gaping mouths can be found, for example, among the bystanders in the *Christ Carrying the Cross* and in the audience in the *Sermon of St John the Baptist*: mankind viewed, in fact, as part of the *Theatrum Mundi*. But Bruegel could also present the human face in all of its complexities of form and expression. As we have seen, this ability appears as early as the *Alchemist* of 1558, in which the

119

166

heads of the fool and the housewife form twin focal points of the composition.

Bruegel's increasing interest in expressive heads during the 1560s is manifested in the London *Adoration of the Magi*, in the wife of Simon of Cyrene in the *Christ Carrying the Cross*, and in the drunken leer of the dancing man at lower left in the Detroit *Wedding Dance*. In the enigmatic *Artist and Connoisseur*, a drawing of about 1565 (Vienna, Albertina), he effectively contrasted the fierce concentration of the painter with the bland, even fatuous expression of his bespectacled companion. During this period, Bruegel also made several studies of individual heads, one representing a countrywoman in profile, 121 the other showing a yawning man. The attribution of the latter 120 picture to Bruegel, occasionally doubted, is confirmed by its similarities in style and execution to the heads in the London *Adoration of the Magi*. This masterfully painted little work may have represented Sloth in the *Seven Deadly Vices* series, as one authority has proposed, but Bruegel's chief concern was most probably the rendering of a face distorted by a huge yawn.

Such experiments in portraying the human physiognomy under varying conditions find their culmination in the Vienna peasant scenes which present a whole gallery of vividly rendered heads. In the *Kermis*, the male dancer in the right foreground and the young man seated by the musician have faces almost portrait-like in character. The brawling peasants at the left have been rendered with a remarkable observation of their psychological reactions. In the *Wedding Feast*, the beer-pourer emerges as a strongly defined personality, as does the choleric elderly man seated at the corner of the table nearest us. In spite of her decorous pose, the bride wears a smirk exuding smug contentment, and in the face of the bagpiper diverted by the *rijstpap*, surely no artist ever more poignantly depicted the 122 anguish of a hungry man. In his ability not only to depict highly characterized heads, but also to suggest states of mind often of the most transient nature, Bruegel was excelled by few artists in European painting and by none in his century.

Despite this vivid realism, many scholars believe that these imposing pictures of peasant life were painted as allegories of human sin and folly. Accordingly, the *Wedding Dance* is seen as a condemnation of lust, the *Wedding Feast* castigates gluttony and the *Kermis* censures those who profane holy days with drinking and brawling. These interpretations find apparent support, perhaps, in what some of Bruegel's contemporaries thought about weddings, carnivals and the like. The moralists of the day complained repeatedly about the licentiousness and unruly behaviour which inevitably flourished on such occasions, and the authorities sought to eliminate these abuses, but to little avail. The engravings of Baltens, Van der Borcht and their German predecessors often show the peasants carousing, quarreling and relieving themselves in public, and this boorish conduct is ridiculed in the inscriptions accompanying some of the prints. Similar disapproval is expressed in the verses which Hogenberg added to his engraving of Bruegel's *Kermis at Hoboken*, even though the revelry it depicts is fairly restrained.

113

114

BRUEGEL'S INCREASING INTEREST IN THE HUMAN PHYSIOGNOMY

120 *Yawning Man,* c. 1564

121 *Head of a Peasant Woman,*
c. 1564

122 The bagpiper sees the food
(detail of 117)

123 Bagpiper and companions (detail of 116)

124 The bride (detail of 117)

Yet, as Alpers was the first to observe, it may be questioned whether Bruegel's paintings of country celebrations were intended primarily to express similar moralizing attitudes. His peasants are often boisterous but, on the whole, they comport themselves with greater dignity than do those satirized in Van der Borcht's peasant scenes, for example. Indeed, the size of these pictures and their carefully rendered details suggest that Bruegel painted the peasants primarily for their own sakes, not without humour, but also with sympathetic insight into their habits and character. In this respect, the *Wedding Feast* and the *Kermis* are not unlike the popular *rederijker* farces in which Jan and Grietje and their fellow villagers act out comic situations with considerable realism of dialect, but with no overtly moralizing intentions.

According to Van Mander, Bruegel and his friend Hans Franckert visited weddings and fairs in the countryside, often disguising themselves as peasants. The authenticity of this anecdote cannot be determined. Perhaps Van Mander was influenced by the realistic character of Bruegel's peasant scenes; if he knew the *Wedding Feast* now in Vienna, he might also have been struck by the resemblance of the bearded man to Bruegel's engraved portrait. Nevertheless, Bruegel's peasant paintings, like the rustic farces of the *rederijkers*, undoubtedly bear witness to the intense interest in peasants and in country life in general which arose in the sixteenth century.

The Netherlandish peasants shared in the general prosperity of the period and were apparently notorious for their lavish wedding celebrations. An Imperial Decree of 1546 limited to twenty the number of guests at country wedding feasts, with what success can perhaps be judged from Bruegel's wedding scenes. These and other village celebrations attracted the city people in great numbers. The citizens of Antwerp, as Monballieu has recently shown, flocked to the near-by town of Hoboken, famous for its cheap beer and several annual festivals. Tielman Susato had already included a 'Hoboken Dance' in his collection of dances published in Antwerp in 1551. Bruegel's

Kermis at Hoboken apparently commemorates the feast of a local archers' guild, celebrated on the Monday after Pentecost. The popularity of country excursions is further confirmed by paintings which show fashionably dressed city-folk strolling through a village festival, such as Beuckelaer's *Peasant Kermis* of 1563 (Leningrad, Hermitage).

Most townspeople probably laughed at the simple, boorish ways of the peasants, but some visitors also must have envied them as representatives of a peaceful and untroubled country life untouched by the cares and corruptions of the city. The contrast of country and city occurs frequently in Virgil's *Georgics* and in other classical literature. Cicero recommended that the merchant should accumulate only enough fortune to retire to the country. Comparable sentiments have probably been expressed in all ages, but they were especially widespread in the sixteenth century, when cities everywhere were growing at an unprecedented rate. At a second *rederijker* competition of 1561, again conducted in Antwerp, the question proposed to the participating chambers for rhetorical treatment was: 'What is the noblest occupation which is most ignored?' The unanimous answer was 'agriculture', and to prove the point, one play included a list of Biblical and classical heroes of peasant origin. Erasmus, Luther and Montaigne all praised the peasant for his honest simplicity, moral uprightness and freedom from city vices, and some writers repeated the old fable that at the end of the Golden Age, Justice had taken refuge among the peasants before fleeing the earth forever. While few of Bruegel's countrymen viewed the peasant in such idealized terms, the busy merchants, statesmen and scholars in the crowded Netherlandish cities would undoubtedly have enjoyed the bucolic visions which he evoked in his pictures of country revelry.

125 Possible self-portrait (detail of 117, see also 1)

LANDSCAPE DETAILS
FROM THE SCENES OF
THE MONTHS
(see also pls. 107,
108, 110)

126 *Hunters in the Snow (January)*

127 *Gloomy Day (February)*

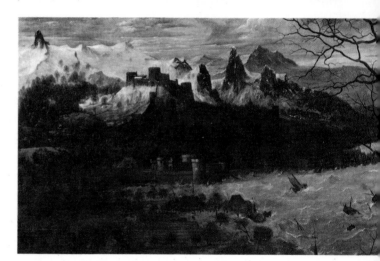

128 *Wheat Harvest (August)*

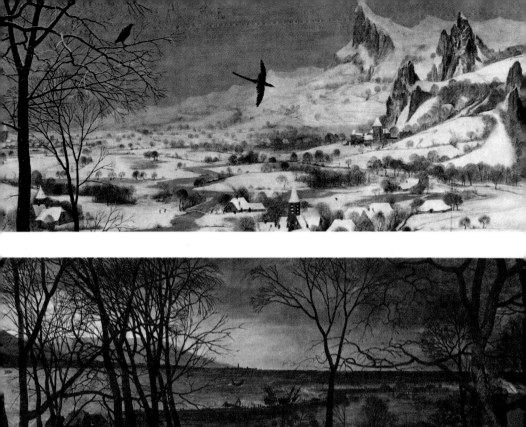

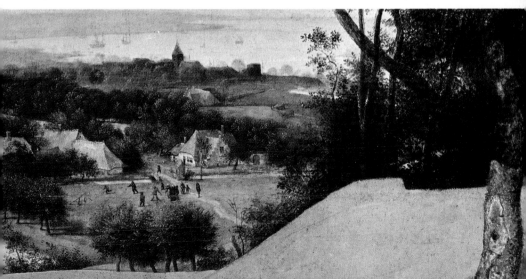

Images of a troubled time

In August 1566, the Feast of the Assumption was celebrated in Antwerp with the usual pageantry, but the new floats which appeared in the procession were more sombre in tone than those of previous years. 'Time Present' was their general theme, and the first tableau showed the 'Theatre of the World' harassed by such personages as Earthly Avarice and Tyrannical Wrath. This was followed by Discord at her spinning-wheel, accompanied by Secret Hate, False Counsel and Self-Interest. The last two wagons, entitled 'God's Foresight' and 'Correct Knowledge', expressed the hope that faith and love would abolish Discord and restore peace and prosperity to the world. Typical displays of *rederijker* allegory, these floats contained no references to specific persons or events. None the less, few spectators would have missed their immediate relevance to the current state of affairs in the Netherlands.

By this time, the long-standing conflict between Philip II of Spain and his Netherlandish subjects had entered a critical phase. As early as 1564, the opposition of William of Orange and other Netherlandish nobles had forced Cardinal Granvella out of the country, leaving behind his magnificent collections of art. Margaret of Parma sought to rule alone in his stead, but was unable to reconcile Philip's insistence on a strict enforcement of the Inquisition with the growing demands of the Protestants for freedom from persecution and the right to worship in public. In 1566 the religious tensions were aggravated by famine, inflation and rising unemployment.

The hopes for a brighter future set forth by the last two wagons in the procession of 1566 remained long unfulfilled.

The iconoclastic riots of that year and the increasing power of the Protestants finally led Philip to dispatch the Duke of Alva with about twenty thousand troops to the Netherlands. Alva replaced Margaret of Parma as governor, and his reign of terror unleashed the events which ultimately split the Netherlands into two parts and toppled Antwerp from her proud position among the pre-eminent cities of Europe.

Economic hardship, persecution and war thus formed the background for Bruegel's last years, but it is precisely during this period that he created some of the finest works of his career. Only two dated pictures survive from 1567, the year of Alva's arrival in Brussels, but no less than five were done in 1568, and it is probably during these two years that he also painted the *Wedding Feast* and the *Kermis*. Significantly, however, far fewer drawings have come down to us from this time. Among them is the *Summer* done in 1568. Other designs were perhaps among the 'biting and sharp drawings' which, according to Van Mander, Bruegel ordered his wife to destroy when he was on his deathbed, 'either from remorse or for fear that she might get into trouble and have to answer for them'.

Van Mander's story has a ring of truth. Public expression of sentiments unfavourable to Church or State was considered seditious by the Government and severely punished. The *rederijkers* were particular objects of suspicion and their plays often supressed. Indeed, the Violeren obtained Granvella's permission to hold the *Landjuweel* (Drama Competition) of 1561 only after great difficulties. In these circumstances, Bruegel's caution is understandable. He may well have agreed with Plantin, who in a letter of 1566 expressed his fear that the Spanish policies of repression would ruin the country. He may also have shared the opinion of his friend Ortelius, who in a letter of 1567 condemned the 'Catholic evil, Protestant fever and the Huguenot dysentery'. But Bruegel's patron Niclaes Jonghelinck was a friend of Philip II and presumably a staunch Catholic, and Jonghelinck's brother Jacob was later to make a large bronze monument commemorating Alva's victories in

the Netherlands. Whatever his private convictions, therefore, Bruegel, like Plantin and Ortelius, probably acted with considerable circumspection during these troubled years.

It is undoubtedly for this reason that the frequent attempts to discover overt anti-Spanish and anti-Catholic propaganda in Bruegel's later paintings generally fall short of convincing proof. The *Sermon of St John the Baptist* of 1566, for example, is thought to have been inspired by the Protestant field sermons which attracted great crowds in the summer of that year. St John's sermon, however, had been a favourite subject of the Flemish landscapists since the time of Patinir, and while Bruegel's version departs from tradition in several respects, no topical allusions can be clearly discerned. Similar interpretations of other pictures may be rejected on the grounds that they were painted several years before the events they supposedly reflect.

One exception, however, perhaps exists in the *Massacre of the Innocents*. As several critics have observed, the grim commander in the centre of the picture may well allude to Alva, for his long white beard bears a remarkable resemblance to the one for which the Duke was famous. The painting may have been done as early as 1566, but fearful rumours of Alva's punitive expedition had circulated in the Netherlands several years before Philip actually sent him. While such paintings of 1568 as 143, 137 the *Misanthrope* and the *Parable of the Blind* may also have been painted as topical commentaries, they are as general and unspecific as the *rederijker* tableaux of 1566.

No topical allusions, however, can be found in Bruegel's 129 *Land of Cockaigne* of 1567; for this picture, he drew upon an old folk-theme whose humour particularly captivated sixteenth-century Europe. A Dutch poem of 1546 describes Cockaigne as a land abounding in food and drink. Pigs and geese run about already roasted, pancakes and tarts grow on the rooftops, and fences consist of fat sausages; these are only a few of the gustatory delights obtainable without cost or effort. To reach this glutton's paradise, the traveller must eat his way through three miles of buckwheat porridge.

178

129 *Land of Cockaigne* 1567

130 Pieter Baltens *Land of Cockaigne*

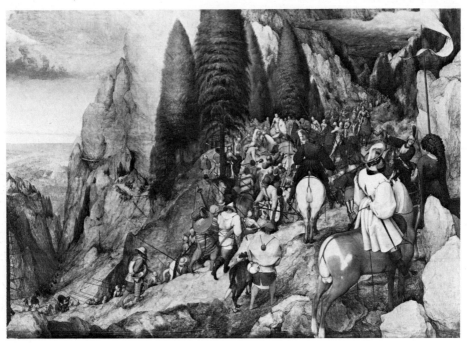

131 *Conversion of Saul* 1567

Bruegel included all these details, but his immediate model, as Lebeer has suggested, was probably an engraving by Pieter Baltens, although he condensed the diffuse, rather prosaic composition of Balten's print into a powerful and concise image. Three representatives of society, a soldier, a peasant and a clerk, sprawl inertly on the ground, their grossly swollen bodies radiating from beneath the tree-table like the spokes of a great wheel. They have gorged themselves into insensibility, especially evident in the gaping mouth and fish-like stare of the clerk. The great curve of the clerk's belly is echoed in the sweep of his fur-lined cloak; he is gluttony incarnate.

The other picture of 1567 shows the miraculous conversion of Saul, later called St Paul, as described in Acts 9:3–8. A

130

131, 132

180

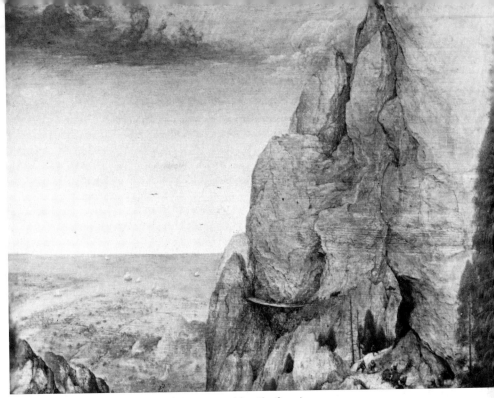

132 Bruegel's most dramatic Alpine scene (detail of 131)

fanatical enemy of the early Christians, Saul was on his way to Damascus to arrest more victims when he was suddenly struck to the ground and blinded by a supernatural light, and heard the voice of the Lord saying, 'Saul, Saul, why persecutest thou my children?' Bruegel depicted Saul's army struggling through a steep mountain pass, its progress halted by the collapse of the leader in its midst. With the crowded composition, the relegation of the chief subject to an inconspicuous place in the middleground, and the sharp contrast in scale between the foreground figures and the others, the *Conversion of Saul* is comparable to several other paintings done in the mid-1560s, such as the *Christ Carrying the Cross* and the *Sermon of St John the Baptist*.

181

The Bible does not describe the terrain in which the miracle occurred. Bruegel's placement of it in a mountainous setting is unusual, although not entirely without precedent. Perhaps inevitably, it has been suggested that the picture commemorates in some fashion the passage of Alva and his troops through the Alps in the spring of 1567. Without doubt, many Netherlanders hoped that Alva, like Saul, would be deflected from his purpose, but Bruegel must also have been aware of the ancient association of the Deity with high places. Moses spoke with the Lord on Mount Sinai, and it was on a high mountain that several Disciples saw Christ transfigured and heard the voice of God. Perhaps this tradition inspired Bruegel to show Saul's conversion on the side of a mountain whose monstrous height almost staggers the imagination. Through the rocks at left can 132 be glimpsed a hazy, blue-green vista lying miles below, and clouds obscure the upper slopes. It is Bruegel's most dramatic Alpine scene.

The pictures of 1568 include four compositions dominated 135, 133 by figures, the *Cripples*, *The Peasant and the Nest Robber*, 143, 137 *Misanthrope* and *Parable of the Blind*. The *Cripples* is one of the smallest of Bruegel's surviving paintings, scarcely eight inches square, and is further distinguished by its fluid brushwork and rich impasto in the highlights. Five crippled beggars hobble on crutches, decked out in their holiday finery. Foxtails dangle from their tunics and several wear paper hats; a similarly dressed cripple appears in Bruegel's *Carnival and Lent*. One of the hats worn in the *Cripples* resembles a mitre, designating the mock bishop who led his fellows in the festivities traditionally accompanying Copper Monday (first Monday after Epiphany) and Carnival; the woman in the background probably collects alms on their behalf, also a carnival practice.

Bruegel, however, has isolated these human wreckages from the carnival ambience and portrays them with apparently little compassion. Their coarse, animal-like faces and mutilated bodies seem almost as monstrous as Bosch's devils, and the resemblance is perhaps not fortuitous. By Bruegel's day,

182

133 *The Peasant and the Nest Robber* 1568

134 Bruegel abandons the landscape panorama (detail of 133)

135 *The Cripples* 1568

beggars had long been regarded as cheats and scoundrels who often faked their deformities in order to attract public charity. 136 In an engraving of cripples and beggars published by the shop of the Four Winds, probably shortly after Cock's death, the accompanying poem characterizes them as servants of the Cripple Bishop who gladly live upon false charity to avoid work. The Cripple Bishop was also included by Jan van den Berghe among the wastrels and deceivers in his *Het Leenhof der Ghilden (Court-Register of the Guilds)*. Bruegel's *Cripples* is, therefore, less a record of contemporary carnival customs than a timeless image of human deceit.

184

Jer. Boſche Inuent. Aux Quatre Vents

Al dat op den blauwen trughelsack, gheefne leeft Daerom den Cruepelen Biſſchop, veel dienaers heeft,
Gaet meeſt al Cruepele, op beyde ſyden, Die om een vette proue, den rechten ghanck myden

136 After Hieronymus Bosch (?) *Cripples, Fools and Beggars*

137 *Parable of the Blind* 1568

138–42
Unsparing physical realism,
but it is also man's spiritual
blindness which is represented

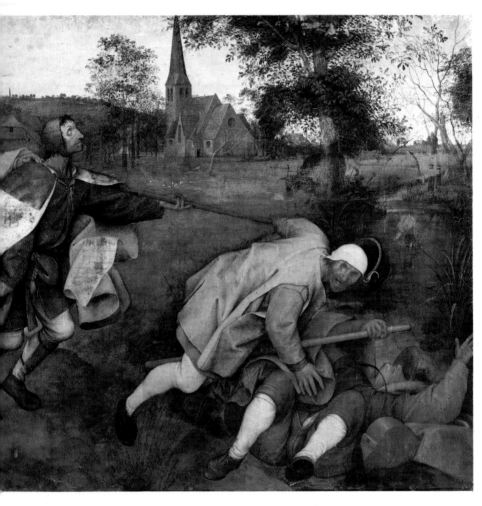

133 Quite different from the miserable creatures in the *Cripples* is the hulking youth in *The Peasant and the Nest Robber*. His powerful forms proclaim him as belonging to the same race as the thirsty mower in the *Summer* drawing, the somnolent inhabitants of the *Land of Cockaigne*, and the lusty revellers in the Vienna peasant scenes. With a complacent, almost vacuous expression, he points towards the left background where a boy has climbed a tree to plunder a bird's nest. This curious subject has inspired several attempts to account for such details as the sack on the ground behind the chief figure and the stream into which he seems about to stride. All we know for certain, however, is that the youth and his companion illustrate an old Netherlandish saying: 'He who knows where the nest is, knows it; he who has the nest, has it.' A commentary on the futility of knowledge unaccompanied by action, this practical advice was also inscribed, probably by Bruegel himself, on his *Beekeepers*, a drawing done about the same time (Berlin, Kupferstich-kabinett). It shows three men, protected by heavy robes and masks, who prepare to capture a swarm of bees, unaware that it has been stolen by a boy with no equipment other than his hat. Here, perhaps, the proverb signifies the futility of prudence and careful planning in the face of daring.

143 The *Misanthrope* is the only one of Bruegel's paintings to carry an explanatory inscription, and even if it was added by a later hand, as one authority has suggested, it adequately describes the subject of the picture: 'Because the world is unfaithful, therefore I go in mourning.' A sour-visaged, melancholy old man stands in a flat landscape, his back to the thief who has crept up to steal his purse. The latter figure represents the world, symbolized by the imperial globe encircling his torso. The misanthrope is not necessarily a miser or a hypocrite, as often assumed, but he is foolish for believing that he can ignore the world's machinations. Even his path into retirement is strewn with man-traps. He is appropriately dressed in a blue cloak; blue was the colour of deceit, as we saw in the *Netherlandish Proverbs*, and here it symbolizes self-deceit.

188

Oﬁu onr dr burrdr is fur cnguru
Oarr oﬂr dba ﬁr rﬁdﬁru

143 *The Misanthrope*
1568 (for detail see
145). Another depiction
of the human condition

The largest and most impressive painting of 1568 is the *Parable of the Blind* which, like the *Misanthrope*, is painted in tempera on linen. Based on Matthew 15:14, 'And if the blind lead the blind, both shall fall into the ditch', this subject had already appeared in the *Netherlandish Proverbs* of 1559, and in several engravings by other artists. One of these was a print published by Hieronymus Cock in the early 1560s. Although this print may have influenced Bruegel, it has little in common with his version. A procession of sightless men shuffles across an open field. The first two have stumbled into a ditch; that a similar fate awaits the others is vividly conveyed by the powerful sloping diagonals formed by their heads and arms and by the edge of the ditch. The steeply pitched roofs in the left background contribute to this falling movement towards the right, to which the staves held by the men afford only temporary relief. The trees and church spire in the landscape behind them provide the only stable elements in the composition.

137

189

144 *Magpie on the Gallows* 1568
(for details see 146)

The pathos of the blind men is heightened by the sombre colours of their clothing, mostly drab greys, subdued greens, blues and purples, and even more by the unsparing realism with which Bruegel represented their infirmities. Several diseases of the eye have been identified, including leucoma, cataracts and atrophy of the eyeball. Nevertheless, these helpless creatures were not painted to arouse our sympathy for their physical condition. Christ had told the parable of the blind to describe the spiritual blindness of the Pharisees, and in the religious controversies of the sixteenth century, both Catholics and Protestants employed it to stigmatize their opponents. Yet it is doubtful that Bruegel's stumbling figures reflect such a narrow sectarian spirit. Like the purblind seekers in *Elck*, they symbolize the spiritual blindness of all men, but with tragic overtones absent in the earlier work. The *Parable of the Blind* is Bruegel's most moving depiction of the human condition.

The paintings of 1568 thus far examined constitute a coherent group within Bruegel's last works. Despite diversities of size and subject-matter, they comment in various ways on man's folly. In this respect they resemble the moralizing scenes of his earlier years, but the differences are even more significant. In the *Netherlandish Proverbs* and the *Children's Games*, for example, the absurdities and follies of the world had been presented as colourful, diffuse spectacles. In these later pictures, on the contrary, human follies are no longer exhaustively catalogued, but epitomized, as it were, in a single motif presented close up to the viewer. And in moving from the detached, panoramic viewpoint of the *Theatrum Mundi* to this more intimate approach, Bruegel generally left behind the mocking humour of his earlier works. Only the bumpkin in *The Peasant and the Nest Robber*, perhaps, is calculated to bring a smile to the observer. The others are more serious, bitter, even tragic; the spirit of the laughing Democritus has given way to that of Heraclitus, the weeping philosopher.

The lower viewpoint and simpler compositions of these late paintings were accompanied by a renewed interest in the local

countryside. As early as 1559, Bruegel had made drawings of Flemish villages and farms, and similar views appear incongruously in the mountain settings of the *Labours of the Months*. Now, however, all vestiges of exotic scenery have vanished. The background of the *Parable of the Blind* shows 137 gently rolling meadows, a pond and a farmhouse. In *The Peasant and the Nest Robber*, thatch-roofed farm buildings and a pond shimmer in the subdued light of a humid, overcast day; 134 this luminous prospect is contrasted on the left side with a shady wood. The trees are rendered with a rapid, almost impressionistic brushstroke and their sturdy trunks seem truer to nature than the decoratively twisted trees in the *Forest Landscape with Bears* of 1554. In the *Misanthrope*, Bruegel evoked perfectly the 143, 145 damp Brabant countryside whose monotonous flatness is broken only by the windmill and some trees. A similar landscape appears in his *Parable of the Unfaithful Shepherd*, now lost, but known to us in several copies, of which the best is in the Johnson Collection, Philadelphia.

Nevertheless, Bruegel did not completely abandon the panoramic style. He returned to it in two other paintings of the period, the *Magpie on the Gallows* of 1568 and the *Storm at Sea*. 144, 147 The *Magpie on the Gallows* is most probably the picture of that name which, according to Van Mander, Bruegel bequeathed to his widow. The foreground is dominated by a huge gallows on which sits a bird, presumably a magpie; a similar bird perches on a neighbouring tree-stump. By the magpie, Van Mander wrote, Bruegel 'meant the gossips whom he would deliver to the gallows'. Babblers and gossipers were traditionally compared to magpies, noted for their chattering, but Van Mander's explanation does not account for other details in the picture, such as the pile of bricks at the base of the wooden cross near by and, above all, the village celebration at lower left.

Whatever the symbolic content of this picture, it is in any case subordinated to the landscape, one of Bruegel's most lyrical settings. The foreground hill slopes down to a forest beyond which we see two mountain ranges divided by a broad river

plain. Compared to the *Labours of the Months*, the *Magpie on the Gallows* seems a deliberate reversion to an earlier landscape style. The delicately painted foliage and the silvery-blue tonalities of the background (which no illustration can adequately reproduce) hark back to Patinir and Herri met de Bles. The little water mill nestled among the trees at lower right also repeats a motif frequently employed by Bles. Yet neither Bles nor any others of Bruegel's predecessors ever painted a landscape like this one, in which the earth is covered by a lush vegetation shimmering in the atmosphere of a soft, hazy day of late spring or early summer. This picture partly compensates us, perhaps, for the loss of the *May* and *June* panels from the *Months*, and it demonstrates how Bruegel continued to infuse new life into landscape formulas established almost a half-century before.

145 The flat Flemish landscape (detail of 143)

146 Return to the panorama (detail of 144)

147 *Storm at Sea, c.* 1569

Despite the ominous gallows, this picture remains a bright interlude among the works by Bruegel discussed in this chapter. Wholly different in character is the *Storm at Sea*. It is neither signed nor dated, and the attribution of this picture to Bruegel has been doubted by some scholars. As we shall see, however, the composition is not untypical of the artist, and its thinly painted surface and lack of detail suggest that the picture was left unfinished at his death. Bruegel had already represented a dramatic storm in the background of the *Gloomy Day*, but here all nature appears to dissolve into chaos. Earth and sky alike are swallowed up in darkness. The purplish-brown water is shot with sickly green lights, its surface broken by huge waves that

147

toss the tiny ships like corks. Nevertheless, a firm structure has been imposed upon this tumult. A large greenish triangle occupies the centre, its two long sides creating a zigzag movement into space; this repeats a compositional device which Bruegel employed in the *Return of the Herd* and other landscapes. Further order is provided by the parallel diagonals of the foreground wave and the patch of blue sky above the harbour in the left distance.

This powerful study of natural violence is not without a deeper meaning. In the foreground a whale pursues a ship whose sailors have tossed a barrel overboard to divert the monster. This method of escaping from whales was first described, it seems, in the *History of the Northern Countries* by the Swedish geographer Olaus Magnus. Latin and French editions of this work were published at Antwerp by Plantin in 1559 and 1561 respectively, but even earlier the phrase 'to throw a barrel to the whale' had acquired a proverbial status. Its meaning is clearly indicated by the Ghent historian Marcus van Vaernewijck. Describing the iconoclastic riots of 1566, he wrote that the angry mobs were encouraged to plunder the countryside in order to divert their destructive attentions from the cities, just as, he explained, 'men cast barrels into the sea for the whale to play with'. Although this expression acquired other connotations for later generations, as some scholars have pointed out, in the sixteenth century it signified the use of subterfuge or the sacrifice of goods or other material advantages in order to avert a greater peril. The message of the *Storm at Sea* would not have been lost on Bruegel's contemporaries during the years when many Netherlanders, including William of Orange, had abandoned wealth and titles to flee Alva's tyranny, and others, like Plantin and Ortelius, remained at home only by disguising their religious and political beliefs. As one of Bruegel's last paintings, it was a grimly appropriate testament to his times.

The most perfect painter of his century

In 1574, some five years after Bruegel's death, Abraham Ortelius wrote the following lines in his *Album Amicorum*: 'That Pieter Bruegel was the most perfect painter of his century no one, except a man who is envious, jealous or ignorant of that art, will ever deny. He was snatched away from us in the flower of his age. Whether I should attribute this to Death who may have thought him older than he was on account of his supreme skill in art, or rather to nature who feared that his genius for dexterous imitation would bring her into contempt, I cannot easily say.'

Despite the rhetorical flourishes, this was a sincere tribute to a beloved friend whose art Ortelius knew well and greatly admired. He ended his eulogy by praising Bruegel's fidelity to nature, without idealizing, and his ability to depict 'many things that cannot be depicted'. In the same year Ortelius commissioned an engraving after Bruegel's *Death of the Virgin* for distribution to his friends; the accompanying inscription, probably by Ortelius himself, praises the artist for his depiction of mixed joy and sorrow in the faces of the Apostles. This understanding of Bruegel's art is in marked contrast to the view of Guicciardini and Lampsonius, who saw Bruegel merely as a talented imitator of Bosch, an opinion echoed by Vasari in the second edition of his *Lives of the Artists* (1568). Undoubtedly this widespread conception of Bruegel was influenced by such works as the *Alchemist* and the *Seven Deadly Vices* which Cock issued as prints and Plantin shipped to Paris, Frankfurt and other cities in Europe.

Ortelius's eulogy thus remains the most sensitive analysis of Bruegel's art which we have from the sixteenth century. We might quibble, perhaps, with his contention that Bruegel was 'the most perfect painter of his century', but even this praise does not seem too extravagant when we consider him within the artistic milieu of his time. Bruegel's designs for prints were more vigorously conceived and usually better drawn than those of Pieter Baltens and Pieter van der Borcht; and his multi-figure Biblical scenes display an animation unmatched by Herri met de Bles and the Brunswick Monogrammist. To the panoramic landscape style begun by Patinir, Bruegel brought a new sense of structure and an unparalleled epic grandeur inspired by his Alpine experience. His later paintings show a synthesis of Italianate compositional principles with the native Flemish realism which was without equal in the sixteenth century. Beside the stilted, mannered peasants of Aertsen and Beuckelaer, the uninhibited merry-makers in Bruegel's *Wedding Feast* and *Kermis* seem as authentic as life itself. Pieter Bruegel represents, in fact, the climax of the indigenous tradition of sixteenth-century Flemish painting.

These qualities undoubtedly help to account for Bruegel's growing reputation after his death. Numerous engravings after his drawings and paintings were issued by the successors of Hieronymus Cock well into the seventeenth century, and his paintings were eagerly collected. If Philip II of Spain was the chief collector of Bosch's works, his Austrian Habsburg cousins displayed a similar enthusiasm for Bruegel. Emperor Rudolph II gathered a number of Bruegel's paintings in his palace in Prague; they included, Van Mander tells us, two versions of the *Tower of Babel* and a *Christ Carrying the Cross*. Some of these pictures may have come from Niclaes Jonghelinck's collection, dispersed after his death in 1572. The Emperor's brother Archduke Ernst, Governor of the Netherlands from 1593 to 1595, bought at least two Bruegels, a *Peasant Wedding* and a *Conversion of Saul*. A later Habsburg Governor of the Netherlands, Leopold Wilhelm (1647–55), also acquired

148 Follower of Bruegel *Peasant Wedding*

Bruegel's work, including *The Peasant and the Nest Robber* and six panels of the *Labours of the Months* once owned by Jonghelinck. These efforts of the Habsburg nobility laid the foundations for the magnificent collection of Bruegel's paintings now in Vienna.

When original pictures by Bruegel were unavailable, the demand for them was met by copies. Almost twenty copies apiece exist of the *Sermon of St John the Baptist*, the Brussels *Adoration of the Magi* and the *Massacre of the Innocents*. Other frequently reproduced compositions include the *Netherlandish Proverbs* now in Berlin and the *Winter Landscape with Bird-trap*. Similarly, the Detroit *Wedding Dance* and several related scenes were repeatedly copied and adapted to new settings. In striking

148

contrast to these pictures, however, there are relatively few copies of the Vienna *Peasant Wedding Feast*, and almost none of the *Peasant Kermis* and the *Labours of the Months*. It has been argued that these particular paintings remained unknown because they had left the Netherlands at an early date, acquired by foreign princes; nevertheless some of them were familiar to Pieter Bruegel the Younger, who copied and adapted them in his own works. It is, therefore, more likely that Bruegel's later monumental pictures found less favour with the general public than his earlier, more anecdotal ones.

If Bruegel's works were thus endlessly multiplied to satisfy collectors, they also exerted a profound effect on the Dutch and Flemish artists who followed him. The history of Bruegel's influence is far too complex to discuss here at any length, and in any case its details are still imperfectly understood. We are uncertain, for example, about his relationship to his former collaborator Pieter Baltens and to his contemporary Maerten van Cleve, both of whom painted Biblical and peasant scenes similar to Bruegel's in style. Equally unclear is his connection with Hans Bol, the somewhat younger artist from Malines whose landscapes show affinities with Bruegel's. That Bruegel took pupils is indicated by Van Mander, who tells us that he used to frighten them with 'all kinds of spooks and uncanny noises'. Nothing is known of Bruegel's workshop, however, and his closest known follower was his younger son Pieter, who did not begin to paint until some years after his father's death.

Nevertheless, Bruegel's scenes influenced Roelant Savery, Adriaen Brouwer and other painters of rustic genre far into the seventeenth century. Perhaps even more pervasive was his effect on later landscape-painting, ranging from the prosaic views of the Flemish countryside by Jacob and Abel Grimmer and the decorative panoramas of Lucas and Maerten van Valckenborch to the airy Alpine prospects of Joos de Mompere. 149 Bruegel's *Return from the Hunt* and his other winter scenes inaugurated a vogue for snowy landscapes which persisted long after 1600. His landscape-drawings were also copied and

149 Lucas van Valckenborch *Summer* 1585

emulated by his successors, and such drawings as the early *Forest Landscape with Bears* may have been prototypes for the views of woods and forest interiors which appeared in great numbers towards the end of the century.

But while Bruegel's art was a potent force in the later history of landscape- and genre-painting in the Netherlands, few of his followers, even the most gifted, seem to have appreciated the monumental qualities of his late works. This was true even of Pieter Bruegel the Younger. Also called 'Hell Bruegel' because of his pictures of the underworld replete with spectacular Bosch-like effects, Pieter the Younger seems to have specialized in copying his father's paintings. He was a competent painter, but his brush flattened the dynamic contours of Bruegel's landscapes and figure compositions. Bruegel's powerful, expansive figures appear deflated, their movements awkward and disjointed. The elder son, Jan Bruegel, was a far greater artist, and he, too, turned to his father's work for inspiration,

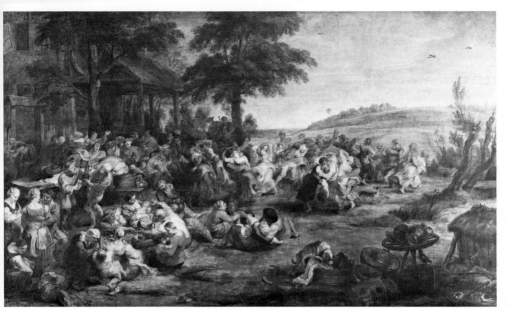

150 Peter Paul Rubens *Flemish Kermis*

particularly in the landscapes. Jan's models were completely transformed, however, through his exquisite, miniature-like style, softly luminous colours and the extraordinary ability to render the textures of rich cloth, flowers and jewels which earned him the epithet of 'Velvet Bruegel'.

It was quite different in the case of Jan Bruegel's good friend Peter Paul Rubens. When Jan placed an epitaph on the grave of his parents in 1625, Rubens adorned it with one of his paintings. This was an entirely appropriate gesture, for he had great esteem for the elder Bruegel. He owned several of Bruegel's paintings, including probably the *Death of the Virgin*, formerly possessed by Ortelius, and he copied another work, now lost, the *Peasants Quarrelling Over a Game of Cards*. And it is evident that Rubens studied Bruegel's works, as well. His late landscapes were composed on a cosmic scale recalling Bruegel's *Labours of the Months*; in his opulent *Return from the Fields*, Rubens paid homage specifically to Bruegel's *Haymaking* in the group of

151

151 Rubens *Return from the Fields* (detail)

peasant women with rakes and hoes at lower right, and in the two sturdy farm-girls near by, almost dwarfed by the huge baskets of produce which they carry. Likewise, the earthy vitality and surging rhythms of Rubens's *Flemish Kermis* clearly bring to mind Bruegel's *Wedding Dance* now in Detroit. Of all later Netherlandish artists, it was Rubens who most fully comprehended the momumentality of Bruegel's later works.

It was natural that an artist of Rubens's stature should have been attracted by Bruegel's formal qualities. The geographer Ortelius, however, chiefly admired Bruegel's incomparable realism; and critics, collectors and casual viewers have always enjoyed Bruegel's robust humour and inventive fantasy. In the twentieth century we have also learned to appreciate his allegorical subjects. That Bruegel's paintings and drawings have elicited so many different responses over the last four hundred years is perhaps the truest measure of his artistic achievement.

152 Bruegel's haymakers (detail of 109) ▷

153 Detail of
Haymaking (109)

Selected Bibliography

Extensive bibliographies of the older literature on Bruegel appear in F. Grossmann, 'Pieter Bruegel the Elder', in *Encyclopedia of World Art*, II, New York 1960, cols. 632–651 (Italian edition, 1958); and R.L. Delevoy, *Bruegel: Historical and Critical Study*, Geneva 1959. The following list includes significant literature published since 1959 as well as some earlier works which are still indispensable.

Surveys

Claessens, B. and J. Rousseau, *Our Bruegel*, Antwerp 1969.

Foote, T., *The World of Bruegel, c. 1525–1569*, New York 1968.

Hughes, R. and P. Bianconi, *The Complete Paintings of Bruegel (Classics of the World's Great Art)*, New York 1967. (Many illustrations and a detailed catalogue of paintings with summaries of scholarly opinion.)

Klein, H.A. and M.C., *Pieter Bruegel the Elder, Artist of Abundance*, New York 1968.

Le siècle de Bruegel, Musées Royaux des Beaux-Arts, Brussels 1963. (Exhibition catalogue of works by Bruegel and other Netherlandish artists of the sixteenth century; profusely illustrated.)

Stechow, W., *Pieter Bruegel the Elder*, New York, n.d. (A judicious survey incorporating the results of earlier scholarship.)

Tolnay, C. de, *Pierre Bruegel l'Ancien*, Brussels 1935.

Paintings

Catalogues

Friedländer, M.J., *Die altniederländische Malerei*, XIV: *Pieter Bruegel und Nachträge*, Leiden 1937.

Grossmann, F., *Pieter Bruegel: Complete Edition of the Paintings*, 3rd rev. ed., London and New York 1973. (First published in 1955, this book includes a thoughtful account of Bruegel criticism since Van Mander; the second volume of this work, described in Grossmann's preface, has unfortunately not yet appeared, but see his valuable survey of Bruegel in the *Encyclopedia of World Art*, mentioned above, as well as many informative articles, several of which are cited below.)

Marijnissen, R. and M. Seidel, *Bruegel*, Stuttgart 1969. (A survey of Bruegel's paintings with extensive catalogue and notes and many excellent illustrations.)

Specialized Studies

Coo, J. de, 'Twaalf spreuken op borden van Pieter Bruegel de Oude', *Bulletin Musées Royaux des Beaux-Arts de Belgique*, XIV, 1965, 83–104. (On the so-called 'Twelve Proverbs' in the Museum Mayer van den Bergh, Antwerp.)

Ferber, S., 'Pieter Bruegel and the Duke of Alba', *Renaissance News*, XIX, 1966, 205–219 (On the *Massacre of the Innocents*.)

Gaignebet, C., 'Le Combat de Carnaval et de Carême de P. Bruegel (1559)', *Annales: Economies, Sociétés, Civilisations*, XXVII, 1972, Part 2, 313–345.

Gibson, W., 'Some Notes on Pieter Bruegel the Elder's *Peasant Wedding Feast*', *Art Quarterly*, XXVIII, 1965, 194–208.

Philippot, A., N. Goetghebeur and R. Guislain-Witterman, 'L'Adoration des Mages de Bruegel au Musée des Beaux-Arts de Bruxelles. Traitement d'un "Tuechlein"', *Bulletin Institute Royale du Patrimoine Artistique*, XI, 1969, 5–33.

207

Roberts-Jones, P., *Bruegel: La Chute d'Icare*, *Musée de Bruxelles*, Fribourg, Switzerland, 1974.

Scheyer, E., 'The Wedding Dance by Pieter Bruegel the Elder, in the Detroit Institute of Arts. Its Relations and Derivations', *Art Quarterly*, XXVIII, 1965, 167–193.

Waźbiński, Z., '"La construction de la Tour de Babel" par Bruegel le Vieux. Genèse d'un symbole d'urbanisme', *Bulletin du Musée National de Varsovie*, V, 1964, 112–121.

Drawings

Catalogues

Münz, L., *Bruegel, The Drawings; Complete Edition*, London 1961.

Pieter Bruegel d. Ä. als Zeichner, Herkunft und Nachfolge, Kupferstichkabinett, Staatliche Museen, Berlin 1975. (Catalogue of an exhibition of drawings by Bruegel, his predecessors and followers, with detailed notes, extensive bibliography and many illustrations; a fundamental reference work.)

Tolnay, C. de, *The Drawings of Pieter Bruegel the Elder*, 2nd rev. ed., London 1952; German edition: *Die Zeichnungen Pieter Bruegels*, Zürich 1952 (first edition, Munich 1925).

Specialized Studies

Arndt, K., 'Frühe Landschaftszeichnungen von Pieter Bruegel d. A.', *Pantheon*, XXV, 1967, 97–104.

Arndt, K., 'Pieter Bruegel d. A. und die Geschichte der "Waldlandschaft"', *Jahrbuch der Berliner Museen*, XIV, 1972, 69–121. (Bruegel's *Forest Landscape with Bears* and related landscape drawings.)

Gelder, J. G., and J. Borms, *Brughels Deugden en Hoofdzonden*, Rotterdam–Schevingen, 1939. (A detailed analysis of the *Seven Vices* and *Seven Virtues* drawings.)

Leeuwen, F. van, 'Figuurstudies van "P. Bruegel"', *Simiolus*, V, 1971, 139–149.

Leeuwen, F. van, 'Iets over het handschrift van de "naar het leven" tekenaar', *Oud-Holland*, LXXXV, 1970, 25–32.

Mori, Y., 'The Iconography of Pieter Bruegel's "Temperantia"', *Journal of the Japan Art History Society*, XXI, 1971, 65–86, 105–116. (In Japanese, with English summary.)

Spicer, J. A., 'The "Naer het Leven" Drawings: by Pieter Bruegel or Roelandt Savery?' *Master Drawings*, VIII, 1970, 3–30 (Van Leeuwen, in the two studies cited above, and Spicer present convincing evidence that the 'naer het Leven' drawings are not by Bruegel.)

White, C., 'Pieter Bruegel the Elder: a new Alpine Landscape Drawing', *Burlington Magazine*, CV, 1963, 560–563. (Preparatory drawing for the *Solicitudo Rustica* print, London, British Museum.)

Zupnick, I. L., 'Appearance and Reality in Bruegel's Virtues', *Actes du XXIIᵉ Congrès International d'Histoire de l'Art*, Budapest, 1969, Budapest 1972, I, 745–753.

Zupnick, I. L., 'The Meaning of Bruegel's "Nobody" and "Everyman"'. *Gazette des Beaux-Arts*, 6ᵉ per., LXVII, 1966, 257–270. (On the *Elck* drawing.)

Prints

Klein, H. A., *Graphic Worlds of Peter Bruegel the Elder*, New York 1963. (Illustrations of sixty-four prints after Bruegel with commentaries.)

Lavalleye, J., *Pieter Bruegel the Elder and Lucas Van Leyden: The Complete Engravings, Etchings and Woodcuts*, New York, n.d. London, 1967.

Lebeer, L., *Catalogue raisonné des estampes de Pierre Bruegel l'Ancien*. Bibliothèque Royale Albert Iᵉʳ, Brussels 1969. Dutch edition: *Beredeneerde catalogus van de prenten naar Pieter Brugel de Oude*. (A comprehensive catalogue of prints after Bruegel with excellent commentaries.)

Riggs, T. A., *Hieronymus Cock (1510–1570): Printmaker and Publisher in Antwerp at the Sign of the Four Winds*, Ph.D. dissertation, Yale University, New Haven 1971. (Authoritative survey of Cock and his printmakers with many references to Bruegel.)

Miscellaneous Studies

Alpers, S., 'Bruegel's Festive Peasants', *Simiolus*, VI, 1972/3, 163–176. (Refutes the current interpretations of Bruegel's peasant pictures as exclusively moral sermons.)

Bedaux, J. B. and A. van Gool, 'Bruegel's Birthyear, Motive of an ars/natura transmutation', *Simiolus*, VII, 1974, 133–155. (Analysing an inscription on a portrait of Bruegel engraved in 1606, the authors conclude that he was born in 1527–8.)

Bergmans, S., 'Un fragment peint du pèlerinage des épileptiques à Molenbeek-Saint-Jean, œuvre perdue de Pierre Bruegel l'Ancien', *Revue Belge d'archéologie et d'histoire de l'art*, XLI, 1972, 41–57.

Franz, H. G., *Niederländische Landschaftsmalerei des Manierismus*, 2 vols., Graz 1969, I, 154–181.

Grauls, J, *Volkstaal en Volksleven in het werk van Pieter Bruegel*, Antwerp-Amsterdam 1957. (Authoritative iconographical studies of *Dulle Griet*, *Netherlandish Proverbs* and other works.)

Grossmann, F., 'Bruegels Verhältnis zu Raffael und zur Raffael-Nachfolge', in *Festschrift Kurt Badt zum siebzigsten Geburtstage*, Berlin 1961, 135–143.

Grossmann, F., 'New Light on Bruegel, I: Documents and Additions to the *Oeuvre*; Problems of Form', *Burlington Magazine*, CI, 1959, 341–346.

Grossmann, F., 'Notes on Some Sources of Bruegel's Art', *Album Amicorum J. G. van Gelder*, The Hague 1973, 147–154.

Jans, A., 'Enkele grepen uit de kerkelijke wetgeving ten tijde van Pieter Bruegel', *Jaarboek van het Koninklijk Museum voor Schone Kunsten, Antwerpen*, Antwerp 1969, 105–112.

Lennep, J. van. 'L'alchimie et Pierre Bruegel l'Ancien', *Bulletin Musées Royaux des Beaux-Arts de Belgique*, XIV, 1965, 105–126.

Monballieu, A., 'P. Bruegel en het altaar van de Mechelse Handschoenmakers (1551)', *Handelingen van de Koninklijke Kring voor Oudheidkunde, Letteren en Kunst van Mechelen*, LXVIII, 1964, 92–110.

Monballieu, A., 'De "Kermis van Hoboken", bij P. Bruegel, J. Grimmer en G. Mostaert', *Jaarboek van het Koninklijk Museum voor Schone Kunsten, Antwerpen*, Antwerp 1974, 139–169.

Renger, K., 'Bettler und Bauern bei Pieter Bruegel d. Ä.', *Sitzungberichte, Kunst geschichtliche Gesellschaft zu Berlin*, XX, 1971–2, 3–20.

Stechow, W., *Northern Renaissance Art, 1400–1600 (Sources and Documents in the History of Art Series)*, Englewood Cliffs, NJ, 1966, 36–41. (English translations of the texts on Bruegel by Ortelius and Van Mander with valuable notes.)

Stridbeck, C. G., *Bruegelstudien*, Stockholm 1956. (Chiefly iconographical studies.)

Terlinden, C., 'Pierre le Vieux et l'histoire', *Revue Belge d'Archéologie et d'Histoire de l'Art*, XII, 1942, 229–257. (An excellent critique of various political and religious interpretations of Bruegel's art.)

Tolnay, C. de, 'Pierre Bruegel l'Ancien, à l'occasion du quatre-centième anniversaire de sa mort', *Actes du XXIIᵉ Congrès International d'Histoire de l'Art, Budapest, 1969*, Budapest 1972, I, 31–44.

Tolnay, C. de, 'Newly Discovered Miniatures by Pieter Bruegel the Elder', *Burlington Magazine*, CVII, 1965, 110–114

List of Illustrations

Dimensions of works are given in inches and centimetres, height preceding width

drawing $8\frac{3}{4} \times 11\frac{5}{8}$ ($22 \cdot 4 \times 29 \cdot 5$). Rotterdam, Museum Boymans-van Beuningen.

34 *Allegory of Prudence*, signed and dated 1559, drawing $8\frac{3}{4} \times 11\frac{3}{4}$ ($22 \cdot 4 \times 29 \cdot 9$). Brussels, Musées Royaux des Beaux-Arts.

35 Pillar-biter. Detail of 44.

36 Dissimulator. Detail of 44.

37 Head-butter. Detail of 44.

38 Devil-binder. Detail of 44.

39 Cat-beller. Detail of 44.

40 Blue cloak. Detail of 44.

41 Landscape background. Detail of 44.

42 Squanderer. Detail of 44.

43 Frans Hogenberg, *The Blue Cloak: Allegorical Scene with Flemish Proverbs*, c. 1558, engraving. Impression in Brussels, Bibliothèque Royal.

44 *Netherlandish Proverbs* or *The Blue Cloak*, signed and dated 1559, panel $46 \times 64\frac{1}{8}$ (117×163). Berlin-Dahlem, Staatliche Museen.

45 Anonymous Flemish artist, *Peasant Village with Proverbs on Sloth*, c. 1550, engraving $14 \times 16\frac{1}{2}$ ($35 \cdot 6 \times 42$).

46 After Maerten van Heemskerck, *Heraclitus and Democritus*, dated 1557, engraving $7\frac{3}{8} \times 10\frac{5}{8}$ ($18 \cdot 8 \times 26 \cdot 2$).

47 *Battle Between Carnival and Lent*, signed and dated 1559, panel $46\frac{1}{2} \times 64\frac{3}{4}$ ($118 \times 164 \cdot 5$). Vienna, Kunsthistorisches Museum.

48 Frans Hogenberg, *Battle Between Carnival and Lent*, dated 1558, etching $12\frac{7}{8} \times 20\frac{3}{8}$ ($32 \cdot 7 \times 51 \cdot 8$).

49 Carnival and his followers. Detail of 47.

50 Carnival merry-making. Detail of 47.

51 Lenten sobriety. Detail of 47.

52 Riding hobby-horse. Detail of 54.

53 Whitsun bride. Detail of 54.

54 *Children's Games*, signed and dated 1560, panel $46\frac{1}{2} \times 63\frac{3}{8}$ (118×161). Vienna, Kunsthistorisches Museum.

55 King Saul. Detail of 56.

56 *The Suicide of Saul*, signed and dated 1562, panel $13\frac{1}{4} \times 21\frac{5}{8}$ ($33 \cdot 5 \times 55$). Vienna, Kunsthistorisches Museum.

57 *Mountainous Landscape with Sunrise*, signed and dated 1561, drawing $5\frac{5}{8} \times 7\frac{1}{4}$ ($14 \cdot 3 \times 18 \cdot 5$). Paris, Louvre.

58 *The Tower of Babel*, c. 1568, panel $23\frac{5}{8} \times 29\frac{3}{8}$ ($60 \times 74 \cdot 5$). Rotterdam, Museum Boymans-van Beuningen.

59 *Landscape with a Village and a Family Walking in the Foreground*, signed and dated 1560, drawing $5\frac{5}{8} \times 7\frac{1}{2}$ ($14 \cdot 3 \times 19$). Paris, Louvre.

60 *Landscape with Rabbit Hunt*, signed and dated 1560, etching $8\frac{3}{4} \times 11\frac{1}{2}$ ($22 \cdot 3 \times 29 \cdot 1$).

61 *Fall of the Rebel Angels*, signed and dated 1562, panel $46 \times 63\frac{3}{4}$ (117×162). Brussels, Musées Royaux des Beaux-Arts.

62 *Dulle Griet*, c. 1562–4, panel $45\frac{1}{4} \times 63\frac{3}{4}$ (115×161). Antwerp, Museum Mayer van den Bergh.

63 Death on a red horse. Detail of 74.

64 School of Joachim Patinir, *The Tower of Babel*, panel $17 \times 11\frac{7}{8}$ (43×31). Present location unknown.

65 *The Tower of Babel*, signed and dated 1563, panel $44\frac{7}{8} \times 61$ (114×155). Vienna, Kunsthistorisches Museum.

66 Upper part of *The Tower of Babel*. Detail of 58.

67 Gerard David, *St Michael*, central panel of triptych, $26 \times 20\frac{7}{8}$ (66×53). Vienna, Kunsthistorisches Museum.

68 Angels. Detail of 61.

69 Dulle Griet. Detail of 62.

70 Anonymous Flemish artist, 'Overhand': the Battle for the Breeches, c. 1560, engraving $14\frac{1}{4} \times 15\frac{1}{8}$ ($36 \cdot 3 \times 38 \cdot 5$).

71 Barthel Behem, *Old Woman Attacking the Devil*, woodcut $10\frac{1}{4} \times 11\frac{3}{4}$ ($26 \cdot 1 \times 29 \cdot 7$).

72 Waste. Detail of 62.

73 Woman and devil. Detail of 62.

74 *The Triumph of Death*, c. 1562–4, panel $46 \times 63\frac{3}{4}$ (117×162). Madrid, Prado.

75 Skeleton army. Detail of 74.

76 Jester. Detail of 74.

77 Solitary death. Detail of 74.

78 Ship sinking. Detail of 74.

79 After Johannes Stradanus, *A Victory of Charles V*, engraving.

80 Army of death. Detail of 74.

81 Hieronymus Bosch, *Haywain* triptych, detail of lovers, central panel. Madrid, Prado.

82 Lovers. Detail of 74.

83 Death plays the hurdy-gurdy. Detail of 74.

84 Christ falls. Detail of 87.

85 Simon of Cyrene and his wife. Detail of 87.

86 Two thieves. Detail of 87.

87 *Christ Carrying the Cross*, signed and dated 1564, panel $48\frac{3}{4} \times 66\frac{7}{8}$ (124×170). Vienna, Kunsthistorisches Museum.

ACKNOWLEDGMENTS

A.C.L., Brussels 16, 17, 34, 61, 62, 101, 105, 120
Bayerische Staatsgemäldesammlungen, Munich 129
Bibliothèque Nationale, Paris 7
Bibliothèque Royale Albert I^er, Brussels (Cabinet des Estampes)
 3, 14, 15, 46, 60, 79, 114, 130
British Library, London 1, 94
British Museum, London 133
Courtauld Institute of Art, London 95
Giraudon, Paris 135
Kunsthandel P. de Boer, Amsterdam 88
Kunstsammlungen der Veste Coburg 90
Mansell Collection, London 151
Mas, Barcelona 63, 74, 81, 82
Musées Nationaux, Paris 59
Museum Boymans-van Beuningen, Rotterdam 136
National Trust, London 93
Rijksbureau voor Kunsthistorische Documentatie, The Hague 64
Rijksmuseum, Amsterdam 45, 48
Schlossmuseum, Gotha 71
Wildenstein & Co., London and New York 11

Index